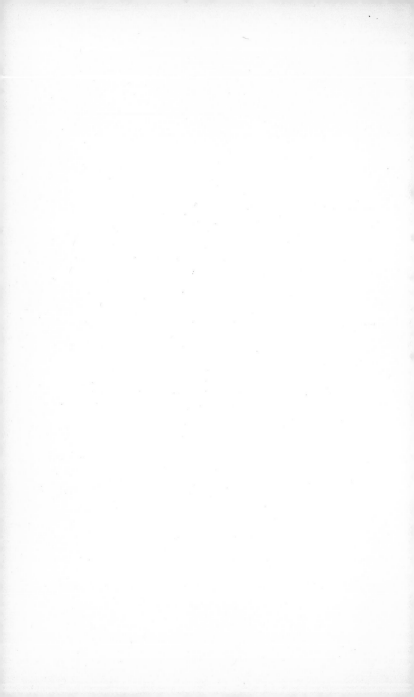

a dictionary of
impressionism

a dictionary of
impressionism

Eyre Methuen

WITH AN INTRODUCTION BY JEAN SELZ
BIOGRAPHIES BY RAYMOND COGNIAT
FRANK ELGAR
JEAN SELZ

Layout design by René Ben Sussan

FIRST PUBLISHED IN GREAT BRITAIN IN 1973
BY EYRE METHUEN LTD
11 NEW FETTER LANE, LONDON EC4P 4EE

© FERNAND HAZAN, PARIS 1972
PRINTED IN FRANCE BY IMPRIMERIE MONNIER, PARIS

IMPRESSIONISM

A way of painting

The history of Impressionism is in the first place that of a group of painters who between 1874 and 1886 decided to exhibit their work outside the official Salon. It is also the history of a way of painting – a way of painting which not only showed its first signs well before the formation of the 'Impressionist' group itself, but also had many and major repercussions on the art of the twentieth century.

What *was* this way of painting? According to the general connotation of the word 'Impressionism' itself, it is the form through which an impression is expressed. This of course implies a difference between a natural scene and our impression of it, and moreover that everyone receives the impression in a different way. But to find the particular pictorial technique to which the term 'Impressionist' applies we must examine the works of its principal exponents. These are comparatively few: Claude Monet, Auguste Renoir, Alfred Sisley, Camille Pissarro and Berthe Morisot are the chief names. All except Renoir were landscape painters, and though Renoir did paint other subjects it is above all in his landscapes that he is an Impressionist.

What is distinctive about the work of these painters, common to all without derogating from the individuality of any, is first a predilection for light colours – the liveliness and variety of their palette. This is especially striking if one compares their

work with that of their predecessors or of the academic painters who were their contemporaries.

They differ also in the way the paint is laid on the canvas with slightly elongated or comma-shaped strokes, apparently without regard for the form of any previously-drawn object, seeming to obey the rapidity of the hand and leave the brush itself free to give or to withhold dimension. Usually, too, different tones which according to another method might have been mixed on the palette are laid on side by side, to form, especially in sunlit landscapes reflected in water (the Impressionists were always attracted by rivers, pools and harbours), a kind of shimmering image which does in fact express the fleeting *impression* received by the beholder. Lastly, the shadows are coloured, and made up of several colours juxtaposed.

So the painter no longer tried to conceal his stroke, and the mobility of his technique extended to every element in the picture – trees, houses, water as well as skies and people. Such were the then revolutionary techniques of impressionist painting. Their novelty, long misunderstood, was to lead to a certain separation of colour and subject, and this is how Impressionism came to represent a break between classical and modern painting and to occupy a major position in the history of art.

The precursors

But other painters long before the Impressionists had used colour with such freedom that they rank as their precursors. To restrict ourselves to the most evident examples, there is first and foremost Frans Hals. When Manet was in Holland in 1872 he paid particular attention to the Hals paintings in the Haarlem Museum. The vigour and in some cases the mobility of the brush-strokes lent a new impetus to Manet's own work, as can be seen in pictures dating from that year on (for example, *Berthe Morisot au chapeau noir*). Manet's

influence on his Impressionist friends was none the less because he always refused to exhibit with them – partly out of dislike for Cézanne's painting, but mainly because he was determined to make his own way in the Salon.

There were also less distant precursors in the first half of the nineteenth century: the English landscapists, especially John Constable and J.M.W. Turner. It is curious to see Constable making as strong an impression on Monet as he did on Delacroix fifty years earlier. Delacroix saw *The Hay Wain* in the Salon of 1824; Monet saw Constable's works in London in 1871. Both must have admired the sense of the open air which took so long to establish itself in French painting, where nature seemed loved less for itself than as the setting for some historical or mythological scene. Constable also encouraged Delacroix to work more freely and to mix his colours on the canvas without having previously blended them on the palette. It was Delacroix's use of 'broken colour' (*le flochetage*, as he called it) which made the Impressionists, and still more the Neo-Impressionists, salute him as a precursor. But he himself made only partial use of this technique, in sections of larger compositions or in small works like the portrait of Chopin. A relationship can also be established between Constable and Boudin. Constable's small beaches and sky studies of the 1820s foreshadowed Boudin's half a century later.

But the Impressionists' greatest shock from across the Channel came from Turner, Turner of the late period, when colour and light seemed to absorb drawing entirely, and dissolve all the subject in atmosphere. Despite Monet's and Pissarro's later reservations – the first accusing him of romanticism, the second of not having properly analysed the colouring of shadows – Turner is the artist who had the most stimulating effect on the growth of Impressionism.

In France the precursors of the movement extend over two generations: that of Delacroix, which includes Corot; and that of Boudin, together with Jongkind, whose vigorous treatment, especially in his water-colours, subserved a constant aim of

fixing the fleeting moments of landscapes lit by turbulent skies. In 1862 he became a close friend of Monet, and on more than one occasion worked with him and Boudin at Le Havre. Between these two generations came the Barbizon painters, who gradually brought about a more naturalistic interpretation of landscape. But Courbet, who has been called 'the leader of the realist school,' is in fact much less of a Pre-Impressionist than the long under-rated Auguste Ravier, whose landscapes consisted of great masses of colour with no definite shapes. Henri Focillon has described his 'dim sun,' with its 'trembling rays throbbing through mist-drenched evenings.'

The Artists' Cooperative Society

The achievement of freedom in methods of painting and choice of subject was accompanied by a similar evolution in social thinking, and the group which between 1866 and 1870 was united artistically around Manet, including Degas, Renoir, Bazille, Fantin-Latour, Cézanne, Monet, Pissarro and others, was also united in the struggle against the restrictions imposed by the Salon juries who systematically rejected their work. The scene of their passionate arguments – sometimes, in the case of Manet and Degas, actual quarrels – was the little Café Guerbois in the Grande Rue des Batignolles, now the Avenue de Clichy. Writers as well as artists went there: among others, Zola, Duranty, and Armand Sylvestre. There various projects were worked out which culminated in the founding of the *Société Anonyme Coopérative des Artistes peintres, sculpteurs, graveurs, etc.* (Cooperative Society of Painters, Sculptors, Engravers, etc.), the solidarity of which was based not so much on identity of aesthetic principle as on a shared hostility to the official authority of the Salon. It was against the Salon and against the conformism of the juries that, under Monet's impetus, a memorable series of exhibitions was eventually held. The war of 1870 and the Commune caused a delay. The group was

temporarily dispersed, Monet and Pissarro in London, Manet near Bordeaux, Cézanne at Aix, Sisley in England, Berthe Morisot first at Saint-Germain, then Cherbourg.

It was not until 1874, from April 15 to May 15, that the Cooperative Society succeeded in holding its first Exhibition, in premises lent by the painters' friend, the photographer Nadar, on the second floor of 35 Boulevard des Capucines, on the corner of the Rue Daunou. The Exhibition included a hundred and sixty-five works by thirty artists, of which the following is a complete list: Astruc, Attendu, Béliard, Boudin, Bracquemond, Brandon, Bureau, Cals, Cézanne, Colin, Degas, Debras, Guillaumin, Latouche, Lepic, Lépine, Levert, Meyer, de Molins, Monet, Berthe Morisot, Mulot-Durivage, de Nittis, A. Ottin, L.-A. Ottin, Camille Pissarro, Renoir, Robert, Rouart and Sisley.

This, the first of the eight exhibitions later to be known as 'Impressionist', had the greatest number of participants, though only a handful were destined to become famous. Renoir showed six pictures, of which *La Loge* (London, Courtauld Institute) was one of the finest he ever painted. Monet showed the picture from which the movement derived its name: *Impression, Soleil levant*, dated 1872. He had had some difficulty finding a title: though painted from his window in Le Havre it was not, properly speaking, a 'view'. It represents the vague outlines of boats and their reflections in the harbour, mingled with the blue mists and pink sky of dawn. It is in fact an 'impression', set down in light touches where colour seems to have no need of drawing – a profoundly poetic impression, but expressed in a pictorial form that might seem sketchy or unfinished, and which was to baffle the public and call down the wrath of the critics.

On April 25 *le Charivari* published an article by Louis Leroy entitled *The Impressionists' Exhibition*. The name stuck, but the article was designed to pour scorn on the exhibitors and their work. The author quoted a visitor as exclaiming in front of the Monet: 'The first sketch of a wall-paper is more

9

finished than that sea-scape!' Jules Claretie wrote that Monet, Pissarro and Berthe Morisot had 'declared war on beauty'. After that, the public came merely to make fun of these 'ridiculous daubs'.

Nevertheless seven other exhibitions followed that of 1874: in 1876 at Durand-Ruel's in the Rue Le Peletier; in 1877 in an empty apartment at No. 6 in the same street; in 1879 at 28 Avenue de l'Opéra (under the title *A group of Independent Artists*); in 1880 at 10 Rue des Pyramides; in 1881 at 35 Boulevard des Capucines; in 1882 at 251 Rue Saint-Honoré; and finally in 1886 on the first floor of the Maison Dorée, at the corner of the Rue Laffitte and the Boulevard des Italiens.

Of the fifty-five participants in the eight exhibitions only one, Pissarro, chose to show every time. Of the rest, Degas, Berthe Morisot and Henri Rouart (an engineer and business man remembered more as a collector than as a painter) were the most faithful, each exhibiting seven times. A certain number of those who had taken part in the first exhibition considered it wiser to abstain thereafter. But other, new names appeared. Among them, to cite only the most well-known, were J.-B. Millet and Caillebotte in 1876; Gauguin, Mary Cassatt, Lebourg, Forain and Zandomeneghi in 1879; Raffaëlli and Vignon in 1880; and finally Seurat, Signac, Lucien Pissarro (Camille's son), Odilon Redon and Schuffenecker in 1886. When one notes that this last exhibition did not include Monet or Renoir or Sisley, it is difficult to speak of a 'group' at all, let alone an 'impressionist group'. In fact for several years the word 'impressionist' had ceased to be applied to these shows.

So in reality the eight exhibitions usually referred to as 'Impressionist' were never more than partly representative of the movement. They served rather to emphasise the differences between the participants than any aesthetic kinship. But it is owing to them and to the scandal they aroused that the impressionist movement established itself, became famous, and acquired a kind of 'status' in the history of painting.

The number of times artists actually took part in the exhibi-

tions bore no relation to the degree of their 'Impressionism'. Monet, who by his work as well as by his leadership, convictions and influence, may truly be called 'the father of Impressionism', only exhibited with the group five times – once more than Renoir and Sisley, twice less than Degas, whose researches led him away from the aesthetic conceptions of his friends. As for Cézanne, he stopped exhibiting after 1877, and his painting, moving towards the constructive tendency from which Cubism was to emerge, came to be definitely opposed to that of the Impressionists.

What was new in 1886 was not so much the disintegration of the group which had almost unconsciously founded the impressionist movement as the emergence, with Seurat, Signac, and their rapidly acquired disciple Pissarro, of a new movement which undertook to codify the problems of colours on a scientific basis, and to frame a theory for a new form of expression. Félix Féneon christened this movement *Neo-Impressionism*, though in fact it blocked rather than continued the freedom the Impressionists had claimed in their work. This way of applying paint in small regular touches is also called 'divisionism', and was popularly known as 'pointillism'.

But the Impressionists pressed on with their work with a resolution which no opposition or hostility could discourage. But it was many years before they were understood, before museums all over the world realised their art was one of the great moments in French painting.

Neo-Impressionists and Post-Impressionists

The Impressionists preferred liberty to theory, and left behind no formal doctrine of their ideas on painting. But their way of expressing themselves and their conception of colour did correspond to the scientific study made forty years earlier by the chemist Chevreul, researches which were complemented after 1878 by the work of Helmholtz, Sutter, and Rood, among

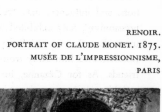

RENOIR.
PORTRAIT OF CLAUDE MONET. 1875.
MUSÉE DE L'IMPRESSIONNISME,
PARIS

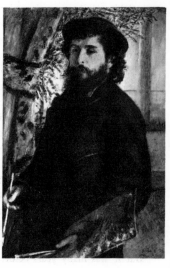

RENOIR.
SELF-PORTRAIT. ABOUT 1876.
FOGG ART MUSEUM,
CAMBRIDGE, MASS.

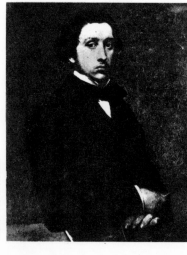

DEGAS.
SELF-PORTRAIT. ABOUT 1854-55.
MUSÉE DE L'IMPRESSIONNISME,
PARIS

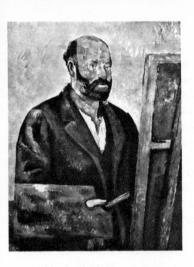

CÉZANNE.
SELF-PORTRAIT WITH A PALETTE.
ABOUT 1885-87.
E. G. BÜHRLE COLLECTION, ZÜRICH

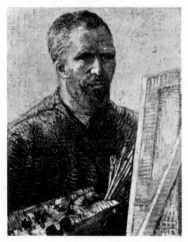

VAN GOGH.
SELF-PORTRAIT
AT THE EASEL. 1888.
VAN GOGH MUSEUM,
AMSTERDAM

PHOTO BULLOZ

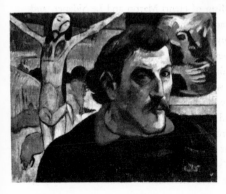

GAUGUIN.
THE YELLOW
CHRIST. 1889.
ALBRIGHT-KNOX
ART GALLERY,
BUFFALO

13

others. It was upon these studies that the theory of 'optical mixture' or 'divisionism' was based. The article on *Seurat* sets out the principles of the theory and describes how Seurat came to be the leader of the Neo-Impressionist School.

The movement was described and defended by Fénéon in reviews like *l'Art Moderne* and *la Vogue*, and found its most ardent disciple, active propagandist and theorist in Signac, who would have preferred to call it 'Chromo-luminarism'. But Seurat, who was not keen on having his paternity of the method challenged (in this he might be said to be the most punctilious of the Pointillists), was by no means delighted with the growing number of his followers. These included Henri-Edmond Cross, Charles Angrand, Albert Dubois-Pillet, Theo van Rysselberghe, Hippolyte Petitjean, Maximilien Luce, Henry van de Velde, Lucie Cousturier, Louis Hayet, etc. Although Neo-Impressionism was a much less important movement than Impressionism itself, and of comparatively limited influence, it is striking to see how many artists were temporarily or otherwise infected by it. This is because the pointillist technique is easily recognisable, whereas the developments of Impressionism, whether distant or immediate, appear in highly differentiated forms. But, as Seurat foresaw, the moment was bound to come when the later applications of Pointillism were no more than a recipe covering such diverse tendencies as the realism of Henri Martin and Le Sidaner, and the futurism of Giacomo Balla, who in 1912, in his *Girl Running on a Balcony*, adapted it to his own technique for representing movement.

But before then the most direct and stimulating effect of Neo-Impressionism was its influence on the Fauves. One of the first to be attracted by it was Henri Matisse: in 1904, when he still had not found his own path, he stayed at Saint-Tropez near Signac and Cross. Their example encouraged him to experiment with the divisionist system (Signac said it was 'a philosophy, not a system') in a picture called *Luxe, calme et volupté* (a quotation from Baudelaire's *Invitation au voyage*),

14

the composition of which presented an obvious relationship with both Cross's *Paysage aux baigneuses* (1894) and Signac's *Au temps d'harmonie* (1895). Matisse's interest in the method became even greater after he had seen the big Signac exhibition at the Galerie Druet in December 1904. But he only used it himself for a few months, and then in a far from rigorous manner. Already in the Neo-Impressionist paintings of 1905, *Pastorale* and *la Femme à l'ombrelle*, one feels Matisse is touched by what in the same year was to develop into Fauvism. This source of Fauvism is also explained by the not exclusive but frequent use made by Seurat's followers, especially Signac, of pure colour. Louis Valtat, Derain, Vlaminck, Braque – nearly all the Fauves had, like Matisse, their pointillist period. The point at which Neo-Impressionism and Fauvism intersect is best seen in certain paintings of Braque, such as *l'Estaque* (1906), where great areas of colour are juxtaposed with the rectangular brush-strokes of a highly-developed pointillism.

The trace of Neo-Impressionism is also to be seen in other painters whose aesthetic lies between Impressionism and Fauvism: in Van Gogh in particular, in 1887, in his *Vues de la Butte Montmartre*. But already his personal tendency towards elongated strokes resembling woven fabric is evident: it was in fact by using bits of wool of different colours that Van Gogh worked out his 'optical mixtures'. The little Japanese box with its spools of wool, now in the Vincent Van Gogh Museum in Amsterdam, is one of the strangest and least known relics of Neo-Impressionism. To the name of Van Gogh must be added that of Gauguin, in 1888; of Van Dongen, around 1905; and of Mondrian, around 1910 and in 1911.

But before that Gauguin had had his impressionist period, and when, having found at Pont-Aven in Brittany the mystical atmosphere that lent itself to his symbolist and 'synthesist' ideas, he adopted a quite different manner, his work was still marked by the love of colour he owed to the Impressionists, and which made him say, 'If you see a blue shadow paint it as blue as possible.' Toulouse-Lautrec was more loyal than

Gauguin to the mobile touch of the Impressionists, and used it from 1886 on to give his people and portraits the same intense life as one finds in Renoir, which seems an extension into the human figure of what Monet and Pissarro had brought to landscape. There is no doubt that if these great models had not been such fascinating examples as to stimulate his own ambitions as a painter and sanction his own ideas on self-expression, Toulouse-Lautrec would never have attained the rare liberty he achieved in his work.

But the extensions of Impressionism are so evident and so extensive it would be tedious and superfluous to trace them all right down into the painting of the twentieth century. The most striking case is that of Bonnard, who might be said to have become an Impressionist in 1910 and remained one until his death in 1947. In Germany at the beginning of the century such artists as Max Liebermann, Lovis Corinth, and Max Slevogt should be counted amongst the Post-Impressionists. If one takes to its logical conclusion the liberty accorded to colour a century ago, one must admit that abstract painting in its most gestural form is one natural consequence of Impressionism.

The Musée de l'Impressionnisme founded at the Jeu de Paume in 1947 contains about five hundred works, including the forty pictures accepted by the State out of the sixty-nine offered to it by the Caillebotte bequest of 1894. It seems scarcely credible today that when all these masterpieces were first received into the Musée du Luxembourg in 1897 they were greeted by violent protests, one orator in the Senate denouncing the Caillebotte collection as 'an insult to public taste' and 'the antithesis of French art'.

CONSTABLE.
1776-1837.
VIEW AT EPSOM.
ABOUT 1808.
TATE GALLERY,
LONDON

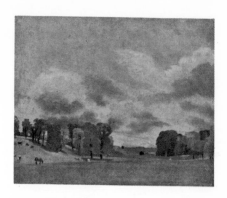

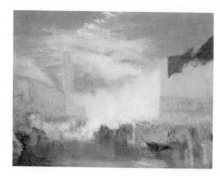

TURNER.
1775-1851.
THE PIAZZETTA.
1839-40.
TATE GALLERY,
LONDON

RICHARD PARKES
BONINGTON.
1802-1828.
LE PARTERRE D'EAU
À VERSAILLES.
1825.
MUSÉE DU LOUVRE,
PARIS

DICTIONARY

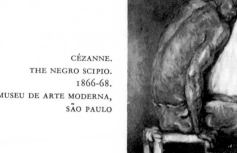

CÉZANNE.
THE NEGRO SCIPIO.
1866-68.
MUSEU DE ARTE MODERNA,
SÃO PAULO

ACADÉMIE SUISSE. In wretched premises on the Quai des Orfèvres, some time between 1825 and 1830, a former model by the name of Suisse (whom they used to call *le Père Suisse*) opened a free academy, provided with models if not with instructors. There one could meet, in 1842, Bonington, Delacroix and Courbet. The Académie Suisse was at its zenith in about 1860, when the future Impressionists frequented it. It was there that Pissarro made the acquaintance of Monet and Guillaumin in 1859, and in April 1861 met Cézanne, who had just arrived from Aix-en-Provence. Cézanne was then twenty-two years old, Pissarro thirty-one. A life-long friendship immediately sprang up between the two artists. Among the regular models of the Academy was a Negro by the name of Scipion, who figures in Cézanne's famous canvas now in the São Paulo Museum. For a long time the Académie Suisse, where artists were completely free, constituted the antechamber of the École Nationale des Beaux-Arts.

ATELIER GLEYRE. If the name of Gleyre, a painter of Swiss origin (1808 - 1874), is remembered at all, it is because he opened a studio to which Monet, Bazille, Sisley and Renoir

used to come in 1862. According to Renoir, Gleyre used to give his pupils a certain freedom. All the same, he one day asked Renoir, 'Do you paint to amuse yourself?' To which Renoir replied, 'Of course, and if it didn't amuse me, believe me, I shouldn't do it.' Monet has described what happened in the live model class. Each Monday, Gleyre used to correct the week's work and the very first week he said to Monet, 'Remember, young man, when you paint a figure, you should always think of antiquity. Nature is all very well as an element in your study, but it is not interesting in itself. There's nothing like style, you know!' It is easy to imagine the effect the Swiss teacher had on the Impressionists, who submitted to it for about one year, just long enough to save his name from oblivion.

BAZILLE Frédéric (1841 - 1870). Born in Montpellier; died at Beaune-la-Rolande. French painter. He went to Paris in 1862, where he attended classes at the Atelier Gleyre while training to be a doctor. He made friends with Renoir, Sisley and Monet and very soon gave up medicine for painting. Bazille had a real talent, but his importance for the early history of Impressionism was as a warm-hearted friend to his more famous companions, whom he often helped in their financial difficulties. His premature death in the Franco-Prussian War prevented him from showing the full measure of his gifts. His painting is very varied, but its general characteristics are bright colours and a pellucid, almost watery quality in the atmosphere. It is difficult to judge what his standing might have been. If his principal work, *Family Reunion* (1867, Musée de l'Impressionnisme) is any indication, he would probably have remained a minor artist. Compared with the undoubted masterpieces of Renoir and Monet, for instance, it is a low pulsed production.

BOUDIN Eugène (1824 - 1898). Born in Honfleur; died in Deauville. French painter. Millet happened to notice his paintings in the window of his bookshop at Le Havre and encouraged him to take up painting seriously. Boudin visited Belgium, Holland and the north of France, fascinated wherever he went by the sea and wide spaces. After returning to the coast of Normandy, he did not leave it again except in 1895, when

GLEYRE. LES ILLUSIONS PERDUES. 1843. MUSÉE DU LOUVRE, PARIS

he went to the French Riviera and Venice. At Le Havre, he met Baudelaire, Courbet, Monet and Jongkind, who was a major influence on him. Boudin, in his turn, was of interest to the Impressionists. He was the painter of the Channel, of sky and limpid atmospheric effects, a soft light playing over the sea and touching into brighter relief the groups of crinolined women on beaches fringed with iridescent waves. His swiftly executed drawings and quick sketches, where his brush flicked off the fleeting, ephemeral forms that caught his eye, are even more attractive than his carefully finished paintings. He is well represented at the Musée de l'Impressionnisme, the museums at Le Havre and Honfleur, and he bequeathed over 6,000 drawings, pastels and watercolours to the Cabinet des Dessins in the Louvre.

CAFÉ GUERBOIS. Situated in Montmartre, at No. 9 Avenue de Clichy, the Café Guerbois was the meeting-place of an artistic circle which, as early as 1866 (but especially during 1868 and 1869), was frequented every Friday by Manet and the writers and art critics Zola, Duranty, Théodore Duret; the painters Bazille, Degas, Renoir, Pissarro, Monet, Sisley, Guys, Stevens; the sculptor Zacharie Astruc, the engraver Bracquemond, and the photographer Nadar. Cézanne only put in a few, brief appearances, but they drew attention to himself.

BAZILLE. FAMILY REUNION. 1867.
MUSÉE DE L'IMPRESSIONNISME, PARIS

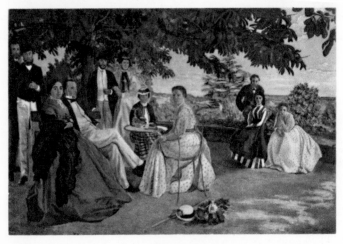

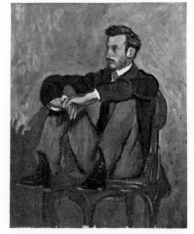

BAZILLE.
PORTRAIT OF RENOIR.
1867.
MUSÉE DES
BEAUX-ARTS, ALGIERS

BOUDIN. COMMERCIAL DOCK, LE HAVRE. MUSÉE DU HAVRE

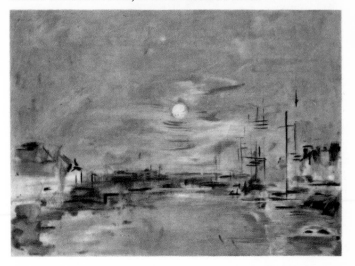

BOUDIN. CRINOLINES ON THE BEACH AT TROUVILLE. 1869.
PRIVATE COLLECTION, PARIS

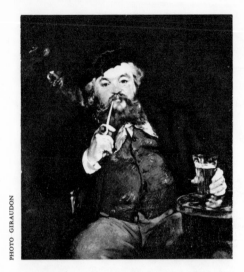

MANET.
LE BON BOCK.
(BELLOT,
THE ENGRAVER, AT THE
CAFÉ GUERBOIS).
1873.
CAROLL S. TYSON
COLLECTION,
MUSEUM OF ART,
PHILADELPHIA

It was at the Café Guerbois that the foundations of the Impressionist movement were laid with such enthusiasm. The artists were either for or against painting in the open air. The other subject that often came up was the art of the Far East, particularly Japanese prints, which the Exposition Universelle of 1867 had given them an opportunity of studying. After the Franco-Prussian war these gatherings were resumed. Manet was always the central figure. About 1876 the group began holding its sessions at the Nouvelle Athènes.

CAILLEBOTTE Gustave (1848 - 1894). Born in Paris; died in Gennevilliers. French painter. Caillebotte's place in the history of Impressionism is similar to Bazille's. Like him, he was a minor painter, a friend of greater artists and a generous patron of their works. His own style is delicate and unadventurous. His most original works are scenes of Paris and the life of its workmen, in contrast to his portraits which are derivative and influenced by Degas. He bequeathed sixty-five Impressionist paintings to the state, but the time was far from ripe for official recognition of the school, and the members of the Institut succeeded in getting them refused. A section at least of

the public already had a taste for Impressionism and the press began a vigorous campaign for their acceptance. Eventually, thirty-eight paintings were chosen out of the collection, but they were not hung in the Louvre till 1928. They include such famous works as Renoir's *Swing* and *Moulin de la Galette*, and Pissarro's *Red Roofs*.

CASSATT Mary (1845 - 1926). Born in Pittsburgh, United States; died at Le Mesnil-Théribus, Oise, France. American painter. Mary Cassatt had a natural attraction to French art; she was descended from French émigrés and her education had instilled an admiration for French culture in her. In 1872, she settled in Paris and, when she exhibited at the Salon of 1874, her work caught the attention of Degas. He introduced her into Impressionist circles and did much to encourage and advise her. Her main subject is mothers and their children, which are painted with a delicate, feminine grace. It was perhaps natural that Degas should influence her more than any other of the Impressionists. Her drawings and engravings are more original. Like the rest of the school, the Japanese print had a profound effect on her and there are some remarkable features in her engravings, which show how intelligently she had assimilated them. Mary Cassatt contributed through her wealth and talents to introducing the Impressionists into the United States.

CÉZANNE Paul (1839 - 1906). Born and died in Aix-en-Provence. French painter. Cézanne left school in 1858, where he had made a close friendship with his fellow-student Émile Zola. Having done well at his studies, he entered a law school, in compliance with his father's wishes. This did not prevent him from carrying on with his drawing classes, which he had been attending since 1856. Hard-working, conscientious, but sensitive and exuberant, he was not a very gifted pupil. He was short, thick-set, very dark, with an unprepossessing face, obstinate forehead, an aquiline nose, a keen glance and quick gestures. He enjoyed swimming, hunting, and long rambles through the countryside. He was fond of music, and played the cornet in the students' orchestra, in which Zola was a flautist. In 1859 his father acquired a seventeenth-century country house,

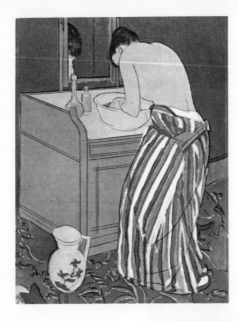

CASSATT.
LA TOILETTE.
PRINT.
1891

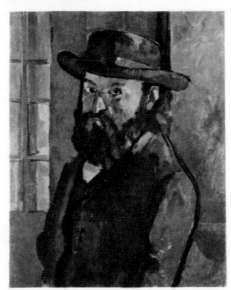

CÉZANNE.
SELF-PORTRAIT.
1880.
KUNSTMUSEUM,
BERNE

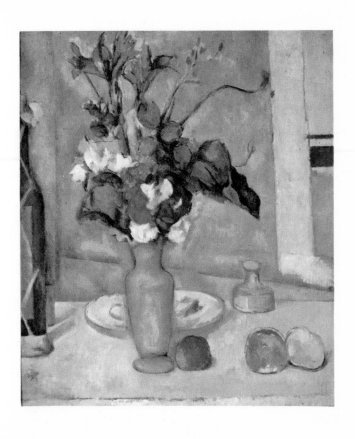

CÉZANNE. THE BLUE VASE. 1885-87.
MUSÉE DE L'IMPRESSIONNISME, PARIS

the Jas de Bouffan, on the outskirts of Aix, and spent the summers there with his wife, his son and his two daughters. There Cézanne set up his first studio. He had already made up his mind about his future; despite his father, who intended that Paul should succeed him as head of the bank, he was going to be a painter. He went on painting secretly, giving his legal studies only moderate attention. Émile Zola, who had settled in Paris, urged him to come and join him there. Cézanne's father opposed the idea. But in April 1861, realizing his son's unfitness for business, and under pressure from his wife and eldest daughter, Marie, he finally gave his reluctant consent. And so Paul Cézanne went to Paris. He took lodgings in the Rue des Feuillantines, studied at the Académie Suisse, became friends with Pissarro and, later, Guillaumin, and resumed his former intimacy with Zola. He was just about able to exist on the 125 francs which his father sent him each month. The tumult of Paris was not at all to his taste, and he was far from satisfied with the first works he produced. Eventually he was refused admission to the École Nationale des Beaux-Arts, on the ground that he had 'the temperament of a colourist' and painted 'with excess'. Discouraged, he went back to Aix, to the great delight of his father, who offered him a position in the bank. But Paul, far from sacrificing the brush to finance, went on sketching and painting with ardour. He painted four large panels, *The Four Seasons*, on the walls of the Jas de Bouffan (today in the Petit Palais Museum in Paris), parodies that he irreverently signed 'Ingres' just for the fun of it. He painted a portrait of himself and one of his father. In November 1862 he went back to Paris. He associated with the Impressionists without, however, being carried away by them. He made the acquaintance of Monet, Degas and Renoir, but the works he admired most were those of Delacroix and Courbet. Cézanne's own work at that period was very romantic. It pleased him no more than it did anyone else. In fact, nothing pleased him, and he was ill at ease everywhere, breaking off a budding friendship, avoiding a famous artist whose work he liked, changing his lodgings constantly, leaving Paris in disgust and going back to it out of curiosity, retiring to Aix and then leaving it soon after. When his work was rejected by the Salon in 1866, he left for Aix, disgusted. He was back in

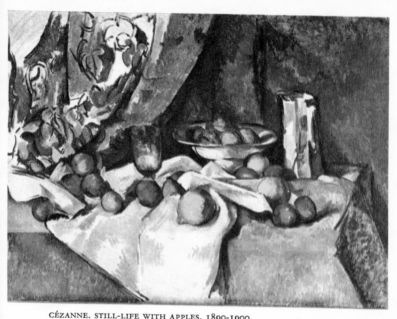

CÉZANNE. STILL-LIFE WITH APPLES. 1890-1900.
LILLIE P. BLISS COLLECTION, MUSEUM OF MODERN ART, NEW YORK

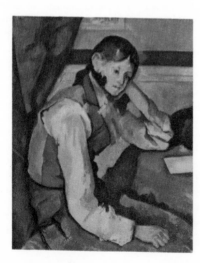

CÉZANNE.
THE BOY IN A
RED WAISTCOAT.
1890-95.
E. BÜHRLE
COLLECTION,
ZÜRICH

official, Victor Chocquet, became his admirer, his confidant, and, on several occasions, his model. From 1874 to 1877, in a studio that he rented at 120 Rue de Vaugirard in Paris, he enjoyed a period of tranquillity and productivity. The *Pool at the Jas de Bouffan* (1874) still belongs to his Impressionist style, but *The Sea at l'Estaque*, painted during the summer of 1876, is constructed according to the principles of a new classicism, an evolution confirmed by the opulent still-lifes which followed, the various portraits of Madame Cézanne, and a series of *Bathers*. He gave up small brush-strokes and the division of tones, and painted in masses. He accentuated volumes, and sought unity of composition. His work gained in thought, firmness, and plastic intensity. The annual rejection of his canvases by the Salon, the raillery of the students at the École des Beaux-Arts, and the persistent incomprehension of the public, intensified his hypochondria. He sent sixteen canvases to the 1877 Impressionist exhibition. The reception was as hostile as in 1874. His father, who had never approved of his artistic career, nor of his liaison with Hortense Fiquet, reduced the already meagre allowance that he made him. That made Cézanne tend to isolate himself even more, to withdraw into himself. He exasperated his mistress with his unreasonableness, his friends with his caprices. Nevertheless, many of them remained devoted, among them the painter Guillemet, who succeeded in having one of Cézanne's pictures exhibited at the Salon of 1882. From then on he lived in Provence, leaving it only for essential trips to Paris, or when he was invited to La Roche-Guyon by Renoir in 1885, or to Hattenville in 1886 by Victor Chocquet.

In 1883 he made the acquaintance of Monticelli. The two artists wandered through Provence on foot, haversacks on their backs, painting side by side, preferably in Gardanne, a little village in the South of France quite close to Aix-en-Provence. In 1886, in the presence of his parents, he married Hortense Fiquet, although he no longer had any feeling for her. In October of the same year his father died, at the age of almost ninety, leaving him two million francs, a considerable fortune in those days. Feeling only repugnance for human society, Cézanne devoted himself exclusively to painting. He had broken with Zola in 1886. His wife and his sister kept house

for him and supervised his son's education. In 1888 he went to live in Paris for a year. He frequently met Van Gogh, Gauguin and Émile Bernard, although he did not care for them very much. He retired finally to Aix, leaving it only for brief trips to Fontainebleau, Giverny, Vichy or Paris. His irascibility increased with the first onset of diabetes. Without any serious reason, he quarrelled with several of his friends, particularly Claude Monet. He painted feverishly, but continued to have doubts about his work. Yet there never was so well-balanced and serene a period in his career as the ten years between 1885 and 1895. That was when he painted *The Chest of Drawers* (Munich), *The Blue Vase* (Musée de l'Impressionnisme) and *Mardi Gras* (Moscow), the *Portrait of Gustave Geffroy*, the three versions of the *Boy in a Red Waistcoat* and the series of portraits of Madame Cézanne. He also painted five versions of the *Cardplayers*, the last of which is in the Musée de l'Impressionnisme, and more than ten versions of *Bathers*, which he treated in the manner of a geometrical problem, striving to determine the laws that governed the composition of the picture. In landscapes his favourite themes at that time were the family property, Jas de Bouffan (he painted its avenue of chestnut trees several times), the village of Gardanne, the Gulf of Marseilles, as seen from l'Estaque (one version in the Musée de l'Impressionnisme) and *Montagne Sainte-Victoire*, notably the one with the big pine tree: in all, more than 250 canvases. His perseverance, if not his stubbornness, was beginning to bear fruit. This was not yet fame, but he was acquiring a reputation. One of his works was shown at the Exposition Universelle in 1889, thanks to the intervention of the faithful Chocquet. When the Théodore Duret collection was put on sale, Claude Monet bought Cézanne's *Village Street* for eight hundred francs, while the dealer Ambroise Vollard exhibited 150 of his works in his gallery in the Rue Laffitte in 1895. The Press was outraged and the public incensed. The academicians turned up to voice indignant protest, but Cézanne's reputation emerged from this experience considerably enhanced. A number of independent painters and new connoisseurs voiced their appreciation. Although he was isolated within the walls of his own mistrust, and overcome with grief at the death of his mother, his lyricism increased and his art glided towards a more expres-

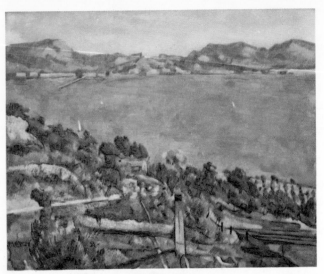

CÉZANNE. L'ESTAQUE. 1882-85.
MUSÉE DE L'IMPRESSIONNISME, PARIS

CÉZANNE. STILL-LIFE WITH ONIONS. 1895-1900.
MUSÉE DE L'IMPRESSIONNISME, PARIS

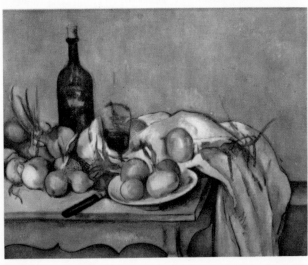

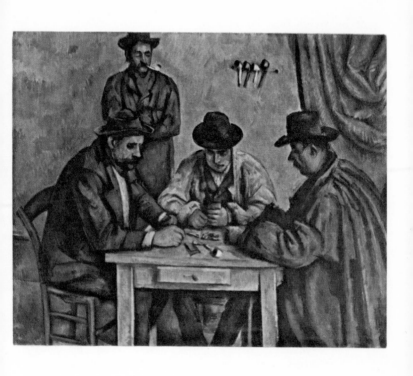

CÉZANNE. THE CARDPLAYERS. 1890-92.
STEPHEN C. CLARK COLLECTION,
METROPOLITAN MUSEUM OF ART, NEW YORK

sionistic style. His feelings for his mother made him decide to sell the Jas de Bouffan and work at the Château Noir instead. He went to Paris for the last time in 1899, then returned to Aix, where he spent his last years, looked after by a devoted house-keeper, Mme Brémond.

In spite of the hostility of the public and official circles, his fame steadily increased. After Victor Chocquet's death, seven of his paintings were sold in 1899 for 17,600 francs. Besides this, one of his landscapes was purchased by the Berlin Museum. He contributed to the exhibition of the Libre Esthétique at Brussels in 1901 and to the Salon des Indépendants in 1899, 1901 and 1902. A room was reserved for him at the Salon d'Automne of 1904. He also exhibited there in 1905 and 1906. It was a triumph. After this, he was accepted by the public, admired by the younger generation and warmly respected. Painters, writers and poets admired him and visited him at Aix. In 1905, he completed *The Bathers* (Philadelphia Museum of Art), which he had begun seven years before. On the 15th October 1906, overtaken by a storm while out painting, he caught a chill and collapsed. He was brought home in a cart, and Madame Brémond hastily summoned his wife and son. They arrived too late. Cézanne died on the 22nd October.

Violent and timid, churlish and kind-hearted, reserved and generous, passionate and level-headed, faint-hearted and proud, brimming over with affection yet distrustful of it in others, eager for honours yet indifferent to fame, small in his life yet sublime in his art, gnawed at by doubts about his work yet convinced of his superiority—such was Cézanne, the most balanced of painters and the most torn by contradictions; for, having repressed his instinct, he could feel it stirring tumul-tuously within him. There was a continuous struggle between the will to organize and the impulse to improvise, between the exigencies of a classical conscience and the pressure of a baroque temperament. Up to 1873 his southern impetuosity and erotic imagination, a fever of subversion and the naïveté of the self-taught, produced a pictorial licentiousness, the dangers of which Cézanne soon perceived. For a while, under the influence of the Impressionists, hoping to get rid of the waywardness of his youth, he tied himself down to a discipline, and subjected his imagination to the laws of Nature. Then began his classical

period. The secret of style was no longer to be found in the delicate play of light or the banal imitation of appearances, but in the severe ordering of forms and the right distribution of colours. In his still-lifes, his portraits, his *Cardplayers*, and his views of l'Estaque or Gardanne, he resorted to an aesthetic system whose principles and appropriate means he discovered for himself; principles and means that issued from his need for perfection, his painful, groping search for an absolute.

To understand properly the prodigious upheaval wrought by Cézanne (since, after him, a radical change occurred in the manner of seeing and in the manner of painting), he has to be seen in relation to the painting of his time. Although he is indebted to Pissarro for freeing him from the excessive romanticism of his youth, developing his gift of observation and his colour sense, nothing was more opposed to his ambition than the empiricist ideal of the Impressionists. He was a Realist as much as they were—even more so, for he wanted to go beyond the 'simple sensation' and the immediate data of the senses. 'To make of Impressionism something as solid and durable as the paintings in the museums', he once said. By sheer will-power and meditation he rediscovered the innate freshness and vigour of sensation, the fundamental sensation that he wanted to make strong and permanent. He built a world whose form, construction and colour ensure permanence and universality. Although he was an ardent admirer of Poussin, Daumier, and Courbet, he wanted none of that form drowned in chiaroscuro and modelling. On the contrary, he disengaged it, encircled it, put it in evidence and accentuated its internal structure. He gave consistency even to air, mist, vapour, to the most volatile and least palpable things in the universe. The sky and sea in his landscapes have as much breadth and solidity as the trees, rocks and houses. 'Nature must be treated through the cylinder, the sphere, the cone', he said, as the Cubists were to repeat later. But reality has three dimensions. How can it be represented on a flat surface? This is where the organizer comes in. With a firm and careful hand, he ordered and combined in the space of the picture the cubes of his houses, the architectures of his trees, the concrete blocks which are his people, the spheres that are his fruits. Verticals and horizontals intersect at right angles to give an effect of magnitude, balance and serenity. Realizing

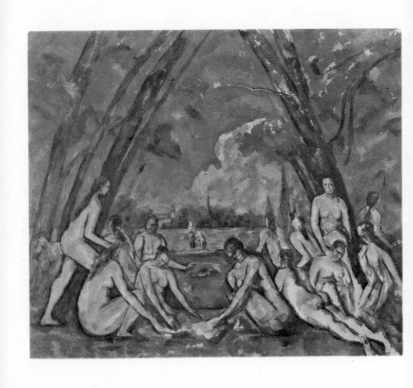

CÉZANNE. THE BATHERS. 1898-1905.
WILSTACH COLLECTION, MUSEUM OF ART, PHILADELPHIA

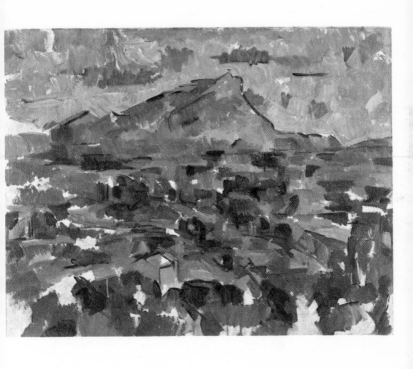

CÉZANNE. MONTAGNE SAINTE-VICTOIRE; VIEW FROM LES LAUVES. 1904-06.
KUNSTHAUS, ZÜRICH

that Nature is 'more depth than surface', he suggested the third dimension by arranging planes in an unexpected manner, by displacing the visual angles, by raising the horizon line (as in l'*Estaque* in the Musée de l'Impressionnisme), without bothering about the rules of perspective as taught in the academies. But how was he to express, at one and the same time, things and the air that envelops them, form and atmosphere, without resorting to the chiaroscuro of the classical painters, or the soft variegations and the shimmering glints of the Impressionists? Rejecting current conventions, Cézanne made a discovery which was to have a far-reaching effect on Western art: light and shadow no longer exist. From now on they are expressed with the aid of colours. Tone takes the place of modelling of form; the relationship of colours takes the place of chiaroscuro. He respects local tone. He substitutes pure tone, and contrasts of pure tone, for the mixture, gradations and modulations of colour. 'Model by the colours', said Antonello da Messina. This suggestion, taken up by the Venetians, has become a definite acquisition, thanks to Cézanne, who invented a pictorial light as different from natural light as a picture is from Nature itself. This difficulty Cézanne triumphantly surmounted. In doing so, he arrived at a new interpretation of volume and drawing. Since form is created gradually by the brush as the artist works, it follows that drawing and painting cannot be distinct from each other. 'When colour has its richness, form has its plenitude', is his famous saying. From that time on the Impressionist division of tone began to give way to the juxtaposition of two opposite tones, the proximity of warm and cool. Each spot of paint becomes a coloured plane, a small, dense, rough-grained mass, placed there by a hand guided by reason, yet full of sensuality and flavour. Cézanne wanted to be a painter to the exclusion of everything else. Nothing counted in his eyes except painting. 'Be a painter', he wrote to Émile Bernard, 'and not a writer or a philosopher.' Disdaining literary subjects, genre scenes and allegorical compositions, he preferred to paint common objects, familiar landscapes, and portraits of humble folk. He did not create his *Bathers* to glorify the splendours of the flesh, or to follow a fashion, but in order to seek new forms and new plastic rhythms. Passionately a painter, he made the picture a concrete and complete world, a reality which is

an end in itself. From this it is easy to understand the profound influence he has exercised over the generation that followed him. He brought them a method, a perfect creation, the 'picture': that is to say, an architecture of tones and forms which is not an analysis of the passing moment, does not represent an anecdote or a chance incident, but is a coherent reality, indestructible and eternal. Cézanne never wanted to betray Nature. He found in himself the heritage of the old masters, which he took and enriched with his own discoveries, and exalted to the extreme limits to which his indomitable courage and genius could bring it. 'To do Poussin over again from nature . . . To make of Impressionism something solid and durable like the art in the museums'—that, in short, was his credo. His work is a lesson in energy. For beyond this robust and balanced art his suppressed instincts rumble, and the man groans, torn between the classicism he has so patiently sought and his latent baroque tendencies. Hence the rickety tables, the crooked vases, the tottering chairs, the stiff limbs, the squint-eyed faces, the sloping postures, the forms that crumble when the vertical and horizontal break, the seeming awkwardness, the distortions that have for so long given Cézanne's hostile critics food for condemnation.

In the last ten years of his life the baroque invades his work without ever overstepping the limits laid down by a lifetime of conscientiousness and effort. He paints still-lifes swaying on slippery supports, views of Montagne Sainte-Victoire shaken by internal fires, trees which seem struck by lightning, *Château Noir* flaming beneath stormy skies. Fauvism is already there, just as Expressionism was in the *Temptation of St Anthony* (1867), and Cubism in the *Cardplayers*. Who of the masters of modern art has not turned to him when in doubt and drawn comfort and inspiration from his example? Matisse, Derain, Vlaminck, and many others have. 'We all start from Cézanne', Braque, Léger and Jacques Villon declared in 1953. On the other hand, the neo-classicists claim him as their model in so far as he remained faithful to the naturalist tradition. Precursor of pure painting, but also promoter of an intellectual adventure that still continues today, Cézanne is a valid source for the non-realists as well as the realists. Destiny chose this torn creature with the anguished heart and confident mind to weave the

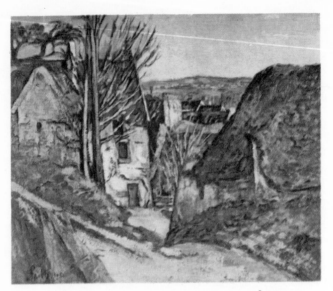

CÉZANNE. THE HOUSE OF THE HANGED MAN. 1873.
MUSÉE DE L'IMPRESSIONNISME, PARIS

RENOIR.
PORTRAIT OF CHOCQUET.
1876.
OSKAR REINHART
COLLECTION,
WINTERTHUR

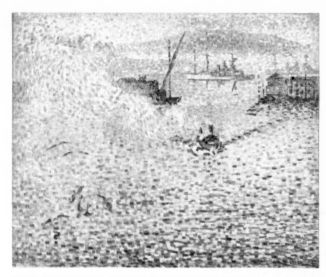

CROSS. THE HARBOUR AT TOULON. PRIVATE COLLECTION, PARIS

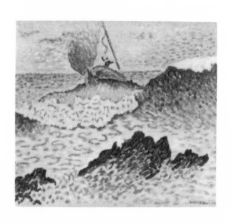

CROSS.
THE WAVE. ABOUT 1907.
M^{me} G. SIGNAC
COLLECTION,
PARIS

threads of a new tradition. 'I am the primitive of the way I have discovered', he wrote one day, in the full consciousness of his originality. There have undoubtedly been other innovators who have had something to give the painters of today, but they are only predecessors. He is the father of modern painting.

CHOCQUET Victor. This enthusiastic and keen collector ('good old Chocquet', as he was called in his time) was born in Lille about 1821. A minor customs official, he devoted a substantial portion of his meagre income to buying Impressionist works. His first acquisitions were a small Delacroix and Manet's *Peonies*, now in the Musée de l'Impressionnisme. In the little shop run by Père Tanguy, a dealer in art supplies and paintings, he discovered the then unknown Impressionist painters, to whom he gave at once his unqualified admiration. In 1875, at the Hôtel Drouot, the Paris auction rooms, he met Renoir at the famous sale organized there by Renoir, Monet, Sisley and Berthe Morisot. The sale was not a success, and they were not even able to pay all the expenses. In 1876 Renoir painted Chocquet's gentle, pensive face, and then made a portrait of his wife. Renoir introduced him to Cézanne, who also painted him several times: first in 1877 and again in the summer of 1889 when he was staying at Chocquet's place at Hattenville, in Normandy. It is indeed amazing that when he died the collection of this minor civil servant comprised, among others, 32 Cézannes, 11 Monets, 11 Renoirs and 5 Manets, as well as some drawings and water-colours. This collection was sold by Madame Chocquet on the 3rd and 4th July, 1899, at a considerable profit. The famous *Mardi Gras* by Cézanne fetched 4,400 francs, a record price for the time. Théodore Duret said that Chocquet showed the zeal of 'a sort of missionary' about Cézanne's works. As an instance, the visitors to the Exposition Universelle of 1889 were able to see the *House of the Hanged Man* because he had agreed to lend an objet d'art only on condition that the work of his friend was also exhibited.

CROSS Henri-Edmond (1856 - 1910). Born in Douai; died in Saint-Clair, Var, France. French painter. His real name was Delacroix, which he used to sign his early work, but it was under his pseudonym that he became famous as one of the finest

of the Neo-Impressionists. His work was hardly known for a long time. He received his preliminary training at Lille from a then obscure painter called Carolus-Duran. He also attended classes in the same town at the Écoles de Dessin et d'Architecture, then in the studio of the Douai painter Dupont-Zipcy. Friendly advice from François Bonvin completed this academic instruction. It produced the classical painter of his earliest known painting, a dark coloured self-portrait, *The Artist Smoking* (1880). For several years, his landscapes and genre scenes *(Washerwomen in Provence)* were painted with a conventional realism. His meeting with Seurat and Signac in 1884 at the first Salon des Indépendants (where Cross exhibited every year till 1893 except in 1885) was the beginning of a development, which, about 1899, brightened his palette and gave his vision a more Impressionistic sensibility. In 1891, this development came to a decisive turning-point when he stayed in the south of France near Signac, a follower of Seurat and enthusiastic advocate of his theories. Cross adopted an uncompromising, Neo-Impressionist technique. His portrait of *Madame Cross* (Paris, Musée National d'Art Moderne), in 1891, was his first Divisionist painting. He even painted the letters of his signature with little dots. He never changed his style but he adapted it in different ways. The severity of his drawing and his carefully studied rhythms related his painting closely to Seurat's until about 1895. The colour range was restricted and often dominated by blue or pale yellow. Works, like *les Iles d'Or* (1891-2), *The Head of Hair* (about 1892) and *Excursion* (1894), help us to understand the reply he gave to a question in his *Notebooks*: 'What is nature? Disorder, chance, holes.' He tried to create 'order and completeness' in contrast to these defects. But even before 1900 and especially after his visit to Venice in 1903, he handled his paint with greater freedom, his strokes became larger, his colours brighter. This development continued till his last picture, *Little Girl in the Garden* (1909).

DEGAS Edgar (1834 - 1917). Born and died in Paris. French painter. He was the son of a banker, Auguste de Gas, and, like Manet, belonged to the upper middle class by birth. His taste for classicism, the correctness with which he conducted himself, seem to be in keeping with his origins, but his exceedingly

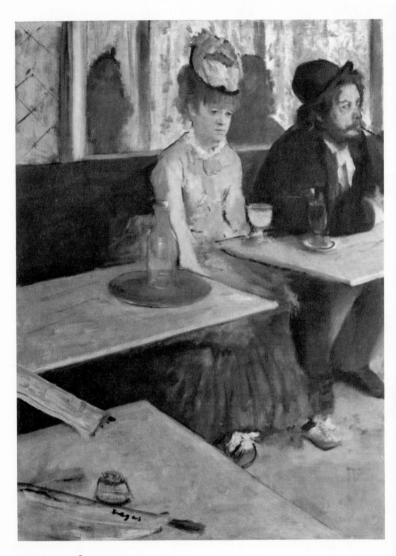

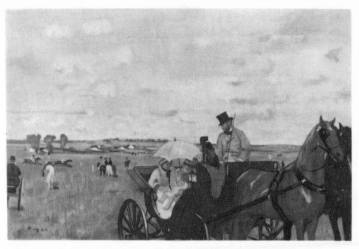

DEGAS. CARRIAGE AT THE RACES. 1870-73. MUSEUM OF FINE ARTS, BOSTON

DEGAS. RACE-HORSES AT LONGCHAMP. 1873-75.
MUSEUM OF FINE ARTS, BOSTON

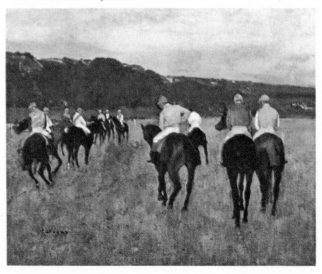

strong personality and independence of mind threw him into the camp of the revolutionaries. He learned to paint at the École Nationale des Beaux-Arts, under Louis Lamothe, a pupil of Ingres, for whom Degas always had a profound admiration. Whatever the evolution of his genius, he was never critical of his early training. No doubt it was his great respect for human creation that was at the bottom of the misanthropy of which he is often accused, and behind which one can sense a deep tenderness. The evolution of his art explains the very special position that Degas occupied in relation to Impressionism. In his earliest paintings, such as *Spartan Girls and Boys Exercising* (1860), *Semiramis Building a City* (1861), and the *Misfortunes of the City of Orléans*, for which he made numerous studies, or even (a little later) the *Cotton Market in New Orleans* (1873), which he painted during his stay in the United States, we are indisputably looking at an extremely classical art, with meticulous draughtsmanship. Little by little, without weakening the rigour of his drawing, he allowed colour to become more and more important. Colour was, however, always subordinated to a realism which would have been dry and narrow had not the genius of Degas brought it a breadth of vision and an originality in composition which saved him from academism, and gave his work a significance far in excess of the place he is given in the Impressionist movement.

Degas certainly belongs to Impressionism because of his desire to capture the fleeting moment, and his concern for presenting exact reality. His division of colour, however, never went so far as the dispersal stressed by the landscapists. Whereas with the Impressionists, form tended to dissolve in the atmosphere, with Degas it kept its density. In fact, unlike them, Degas wanted to sum up the living world within strictly determined limits: he had no taste for suggesting the rustle of leaves, the shimmer of water, or the changing effects of the sky. When landscape does intrude into his composition—in his race-course scenes in particular—it never gives the impression of a work executed on the spot; nor does one feel, with him, that Nature was necessary to his inspiration. The picture-dealer Ambroise Vollard records this significant remark made by Degas: 'The air which one breathes in a picture is not the same as the air one breathes outside'. He did not seek chance beauty

improvised by Nature, he preferred that created by man. He preferred the artificial light of the theatre to sunlight. He was interested in the human presence, and never treated the silhouettes of his figures in the casual manner of the other Impressionists. In that way his art was not a repudiation of the Classicism glorified by Ingres, but actually an extension of that formula enriched by new experiences. All these points, on which he differed with his friends, are not, in fact, sufficient to exclude him from the Impressionist movement—in the first place, because Degas himself decided otherwise (in fact, he participated, from the beginning, in a number of their exhibitions, at a time when this participation meant taking a stand, a declaration of war); but, above all, it should be understood that although he had his differences of opinion with Monet, Sisley and Pissarro, he did not oppose the new school but, with Cézanne, completed it. Cézanne, it will be remembered, wanted to make of Impressionism a solid painting like that of the museums. One might say that Degas dreamed of creating a museum painting as living and modern as that of the Impressionists. Whereas Monet, Sisley and Pissarro sought the maximum possibilities of colour, and Cézanne did the same with respect to volume, Degas cherished an equally tenacious passion for drawing. 'I am a colourist with line', he said. He

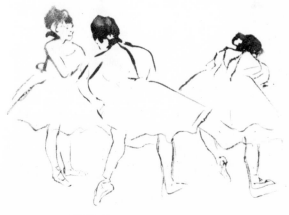

DEGAS. THREE DANCERS. DRAWING.

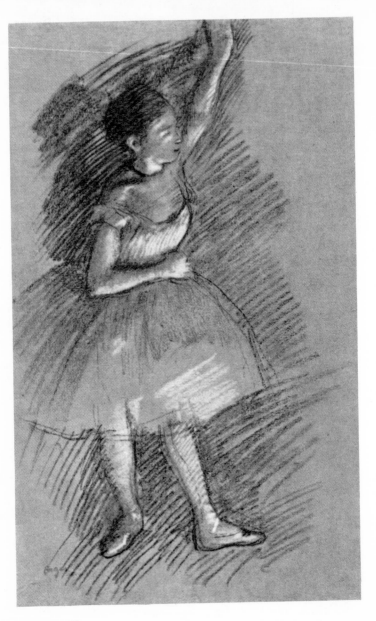

← *Opposite*
DEGAS.
DANCER, STANDING.
1879-1882

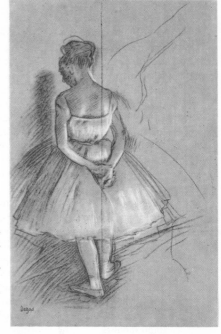

DEGAS.
STUDY FOR THE PAINTING
IN THE MUSÉE DE
L'IMPRESSIONNISME:
'REHEARSAL OF A BALLET
ON THE STAGE'. 1874.
PRIVATE COLLECTION

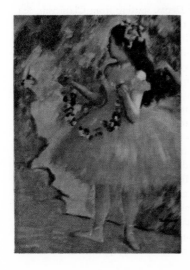

DEGAS.
DANCER IN A PINK DRESS.
ABOUT 1880.
CHAUNCEY McCORMICK
COLLECTION,
CHICAGO

drew, and colour came only to complete, by its material and fixative quality, what the drawing had caught of the dynamic reality. Drawing was, for him, the result of swift observation. It was necessary to see quickly, and the mind must be able to select; painting was the result of a series of verifications, and did not require the same inventive qualities. Slowly, however, he began to discover the wider limits of colour. He began to seek in it something more than local tone, and the means of characterizing a volume. From then on colour brightened the body surfaces, caught the light on the filmy *tutus* of the dancing girls, and produced some of the most glamorous and fairylike scenes of the close of the nineteenth century. These dancers, these women at their toilet, are certainly neither intelligent nor beautiful. They are commonplace, often vulgar in their physique and in their poses, but Degas strips them of matter, picking out only the essential rhythms of their movements, making beauty itself spring from the banality or vulgarity of their gestures. He does it so naturally, so completely, that he never gives the impression of resorting to artifice in order to transfigure reality. His was a more complex, intellectual creation than those achieved by most of the other Impressionists.

One thing is certain: if Degas, starting from Classicism, felt isolated in the midst of those who claimed to have broken with the past, he was still more opposed to those who wished to preserve it with a dismal and narrow fidelity. The deep hostility and spirit of revolt that made Degas reject all the academic formulas transmitted by the École des Beaux-Arts, can never be sufficiently stressed. This stubborn search for the new, the hitherto unattempted, was with Degas more a means than an end. He wanted to cast off all that was conventional, trite or commonplace, in order to transcribe reality without having anything impede or distort his vision. Degas is really the first artist in whom indifference to all that was not real was carried to its extreme. His attitude is similar to that of the zoologist, or the physiologist. He outlines a human attitude as a doctor describes a clinical case. It is therefore Naturalism that transformed this traditional artist (as he was at first) into one of the most daring innovators in the transcription of the scenes of modern life. But this search, however persistent, was never

provocative. Breaking with the accepted conventions, his *Portrait of the Bellelli Family*, which he painted when he was only twenty-six, contains a real stage setting, which must have surprised his contemporaries somewhat. Degas portrayed M. Bellelli with his back turned, seated in an armchair, an arrangement which was hardly in conformity with custom. In his pictures of this period, no matter how traditional they might be, he seemed to be already avoiding static forms, seeking instead the effect of photographic instantaneity, which was to become characteristic of all his work. His *Cotton Market in New Orleans* (1873) is a synthesis of his art over a period of years: audacity in the placing of the subject, very important foreground, scrupulously exact draughtsmanship, and a very solid, though somewhat conventional perspective. Without a doubt this very need to represent life led him to paint his characters at work, such as laundresses, milliners (1882-1884), surprising them in characteristic attitudes. For several years before then dancers had revealed to him the resources of the human body, and shown him what an artist who cared about draughtsmanship could find in the acts of everyday life. It is only natural that the name of Degas should conjure up, for the less informed, dancers in *tutus*, practising their points, tying their shoe ribbons, or revolving about the stage from strange perspectives with oddly foreshortened bodies. For these dancers represent Degas's decisive contribution to the Impressionist movement. They represent the very movement of perpetually changing reality surprised, immobilized—that obsession of the artists of the period. However, the reality seen by Degas is his own: anxious to express the maximum of life, he selected aspects of reality that had never been observed before, and were thus more striking in their truth. His nudes—women at their toilet— reveal attitudes that do not appear very natural, the limbs being contracted in awkward gestures. For the same reason he tried to get from light effects which were contrary to natural lighting; he tried to capture the light of the footlights, which rises from the floor, inverts shadows, transforms faces, and brings gestures out in unusual relief. Degas went beyond this stage in the expression of movement and took up sculpture: his statuettes of horses and dancers became a real arabesque in space, and the analogy of gesture between dancer and horse,

DEGAS. LA COIFFURE. 1892-95. NATIONAL GALLERY, LONDON

DEGAS.
THE LAUNDRESSES.
ABOUT 1884.
MUSÉE DE
L'IMPRESSIONNISME,
PARIS

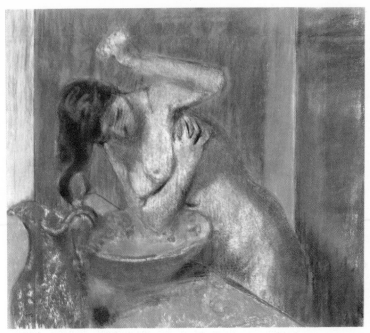

DEGAS. WOMAN AT HER TOILETTE. 1892.
RUDOLF STAECHELIN COLLECTION, KUNSTMUSEUM, BASLE

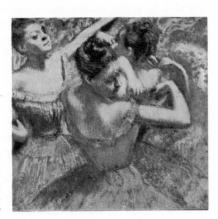

DEGAS.
DANCERS.
1899.
MUSEUM OF ART,
TOLEDO, OHIO

the same way of nervously extending the leg, reveals his keen and exacting observation.

If Degas belongs to Impressionism, it is by his mental disposition rather than his technique, by his clear refusal to accept a conventional world. Study gave him a technique; the spectacle of reality gave him a sense of life. Degas appeared to divine the potentialities of the modern world to a far greater extent than his friends did. It is no mere accident to find in his work a forecast of new ways of disposing figures on the canvas, and unexpected angles of vision which, many years later, photography and the cinema were to use. His views seen from above, his method of depicting the main figure in a portrait off centre, of giving the foreground unexpected importance in relation to the subject as a whole, of putting the emphasis on an inert and accessory detail in order to accentuate, by contrast, the expression of life in a face—all these innovations correspond exactly to what the camera gives us today. In *Le Secret Professionnel* Jean Cocteau writes: 'I have seen photographs that Degas enlarged himself, on which he worked directly in pastel, amazed by the arrangement, the foreshortenings and the distortion of the foreground'. But that is reducing too much to chance the part played by the artist, without taking into account the sharpness of his magnificent drawing, which goes far beyond instantaneous photography, no matter how exceptional that may be. These new possibilities interested him only in so far as they enabled him to emphasize the everyday action. Degas always refused to paint from Nature. Although, in his work, he gives an impression of spontaneity, of having captured a gesture or pose at a dress rehearsal in the theatre, or on the race-course, his pictures are all studio productions, the results of long hours of hard work under conditions where, unlike the artist who works from Nature, he is not limited by time. His painstaking drawings were made from memory, or from 'notes'. At a time when some painters were proclaiming their desire to depict their passing impressions, Degas's profound and patient observation produced masterpieces full of the feeling of life.

He brought the same research approach to the problems of technique, and there, too, his classical sense, far from limiting him, impelled him to seek that mastery of his craft which the

painters of the past had had. Though he used the most varied mediums, he found pastel the one that suited him best. Sometimes he used different mediums in the same picture, or else he would superimpose coats of pastel in order to obtain, as in oil-painting, a play of transparencies between the strokes. Towards the end of his life, his sight failing, he developed a preference for working in charcoal, multiplying the sharp, nervous strokes, often enhancing them with pastel. Degas is as indispensable to the history of Impressionism as Renoir, Monet, Cézanne. Even if his work has had less influence than that of Cézanne, it contains enough mystery to enable it to be rediscovered one day for reasons which we do not suspect, and which will, perhaps, be far from those for which we admire him today.

DURAND-RUEL Paul (1831 - 1922). The influence of the great picture dealers on the development of painting in the nineteenth and twentieth centuries has been considerable, probably owing to the fact that at the beginning they acted, more often than not, out of disinterested enthusiasm. Durand-Ruel's gallery was first at 1 rue de la Paix, then in 1867 he moved it to 16 rue Laffitte. He was first a friend of Corot, Millet, Théodore Rousseau, Daubigny and Boudin, and gave them both moral and material support, sharing their enthusiasms and their disappointments, and disposing of their canvases for them, often with reluctance. He was most heroic in his backing of the Impressionists in 1870. In 1871 he fled to London, and there made the acquaintance of Monet and Pissarro. On his return to Paris in 1872 he bought twenty-three canvases from Manet for 35,000 francs. For more than ten years Durand-Ruel did his utmost to popularize the Impressionist works, which no one wanted and everyone condemned. Manet, Renoir, Monet, Sisley, Cézanne, Degas and Pissarro became his friends. He was really a philanthropist, and narrowly escaped bankruptcy before he succeeded in interesting America in the new school in 1886. In the history of Impressionism his name is linked particularly with the second exhibition of the group, which he arranged in his premises at No. 11 Rue Le Peletier in 1876, as a protest against the pigheadedness of the official Salon, which refused to accept the adherents of the new school. It was because of this exhibition that Duranty

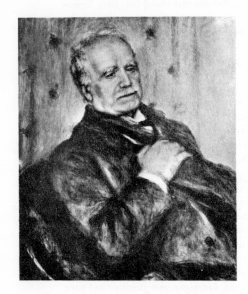

RENOIR.
PORTRAIT OF
PAUL DURAND-RUEL.
1910.
PRIVATE COLLECTION

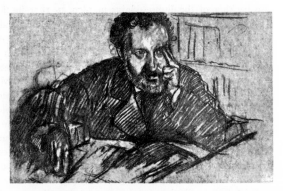

DEGAS. PORTRAIT OF DURANTY. 1879.
METROPOLITAN MUSEUM OF ART, NEW YORK

MANET. PORTRAIT OF THÉODORE DURET. 1868.
MUSÉE DES BEAUX-ARTS DE LA VILLE DE PARIS

wrote his famous book in support of *The New Painting*. The stubborn refusal of French collectors to accept the Impressionists made Durand-Ruel decide to open galleries in London, Brussels, Vienna, and finally in New York in 1887. Renoir has left a fine portrait of this great collector and picture-dealer, dated 1910. Today, Durand-Ruel's gallery has been moved to the avenue de Friedland and is run by his grandsons.

DURANTY Louis Edmond (1833 - 1880). This little-known novelist of the French realist school was one of the most ardent supporters of Impressionism right from the start. In his impassioned articles in the *Gazette des Beaux-Arts* he traced the relationship between the Impressionists and the Venetians and Constable. In 1876 he published his book *The New Painting: Concerning a group of artists exhibiting at the Durand-Ruel Gallery*, in which he developed some very accurate views. Taking to task the very official École Nationale des Beaux-Arts for inspiring in its young pupils 'a strange system of painting bounded in the South by Algeria, in the East by mythology, in the West by history, and the North by archaeology', he hailed the works of the Impressionists, all of them inspired (so he wrote) by things of their time. After paying tribute to Courbet, Corot, Boudin, and, in particular, Manet, whom he regarded as the initiators of the new painting, he extolled the great work begun by Monet, Degas, Pissarro, Sisley and Berthe Morisot. He was the friend of many painters and writers, and was included by Fantin-Latour in his painting *Homage to Delacroix*, together with Manet and Baudelaire. There is a well-known portrait of him painted in tempera by Degas.

DURET Théodore (1838 - 1927). French writer and art critic, a contemporary of the Impressionists and one of their first supporters. However, in his *The French Painters*, published in 1867, Duret, not being sufficiently informed, strongly criticized Manet, who had already painted *The Fifer* and *Le Déjeuner sur l'Herbe*. The matter was evidently straightened out, as Manet painted his portrait (now in the Petit Palais, Paris) the following year. Meanwhile, in 1873, he went to Japan and came back full of enthusiasm for Japanese art. 'The Japanese', he wrote, 'were the first and most perfect Impressionists.' In 1878 he published

his *Impressionist Painters*, this time praising them unreservedly. The book included monographs on Monet, Sisley, Pissarro, Renoir and Berthe Morisot. Manet was presented as the initiator of the movement. In a revised edition which appeared in 1906 the author added studies of Cézanne and Guillaumin. His catalogue *Manet and His Work* was not published until 1902.

FÉNÉON Félix (1861 - 1944). French writer and art critic. He was a friend of Seurat and Signac, and became the spokesman of Neo-Impressionism, setting out its basic principles in a kind of pamphlet under the title of *The Impressionists in 1886*, which was a great success. Using the scientific theories of Chevreul, Sutter, Charles Henry and O. N. Rood, Fénéon explained the Neo-Impressionist methods, and did so with a warmth and conviction that earned him considerable support. Although he railed against Gauguin, and criticized (though not without respect) Monet, Degas and Renoir for not having systematically applied the principle of division of colour, he adopted a milder attitude toward Pissarro, who had allowed himself to be for a while attracted by Divisionism, and championed Seurat, Signac, Cross and their friends unreservedly. The same year, 1886, Fénéon contributed an article on Seurat and Divisionism to *Vogue*, a Symbolist review. It was, however, in *Art Moderne*, a Belgian periodical whose correspondent he was in Paris that he published some of his most important articles from 1886 to 1890. Afterwards, he became one of the regular contributors to the *Revue Blanche*, founded by the Natanson brothers in 1891. In 1900, he organized an outstanding retrospective exhibition of Seurat's works on the premises of the review. Furthermore, faithful to his friend's memory, he took it upon himself, after Seurat's death, to compile a complete catalogue of his works.

Although he loved order and logic, he was never at any time insensitive to the painting of young artists, such as Vuillard or Bonnard, whom he got to know in 1891, and with great perspicacity he supported the Nabi movement from its inception. He was an ardent admirer of Toulouse-Lautrec, who depicted his curious silhouette in the two panels: *Danse de la Goulue* et *Danse des Almées*, which he executed in 1895 for the dancer's booth at the Foire du Trône. There are numerous portraits of Fénéon, but the most symbolical is the one Signac

TOULOUSE-LAUTREC.
PORTRAIT OF FÉNÉON.
DETAIL FROM THE PANNEL
FOR LA GOULUE'S BOOTH.
1895.
MUSÉE DE
L'IMPRESSIONNISME,
PARIS

SIGNAC. PORTRAIT OF FÉLIX FÉNÉON. 1890.
JOSHUA LOGAN COLLECTION, NEW YORK

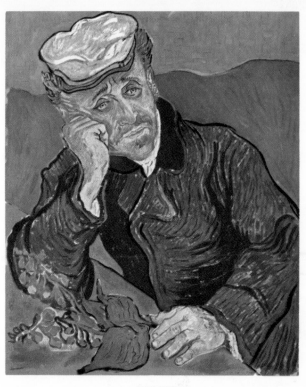

VAN GOGH.
PORTRAIT OF DR. GACHET.
JUNE 1890.
MUSÉE DE
L'IMPRESSIONNISME, PARIS

DR. GACHET.
VAN GOGH ON
HIS DEATH-BED.
DRAWING. 1890.
MUSÉE DE
L'IMPRESSIONNISME,
PARIS

left, with a title that must have enchanted Fénéon himself, *Sur l'émail, d'un fond rythmique de mesures et d'angles, de tons et de teintes, portrait de M. Félix Fénéon en 1890.*

GACHET Dr Paul (1828 - 1909). Born in Lille; died in Auvers. His innate taste for painting and abiding friendship for painters, rather than the collector's urge, prompted Dr Gachet to gather around him at his home in Auvers-sur-Oise the greatest painters of his time. Not only Cézanne and Van Gogh but Pissarro, Renoir, Monet and Guillaumin were frequent visitors at the doctor's home. He became fond of them all, and their friendship went far beyond the usual relations between artist and collector. The relations between Doctor Gachet and Van Gogh were particularly close. After leaving the asylum at Saint-Rémy, Vincent, on the advice of Pissarro, went to stay at Auvers on May 16th, 1890, and saw much of the doctor, who was the artists' physician as well as their benefactor. Their friendship was to be short and tragic, for it ended, on the 27th of July, with Van Gogh's suicide. Dr Gachet had tried, with the utmost skill and discretion, to persuade Vincent that he was not so ill as he thought. He gave him a measure of confidence in his abilities. In his calmer moments Vincent showed a tender affection for the doctor and his wife. In June he painted a picture of *Mademoiselle Gachet at the Piano* and the celebrated portrait of the doctor wearing his famous white cap. When Van Gogh shot himself near the heart on the evening of July 27th, Doctor Gachet tended him for two days in a desperate effort to save him. Gachet has left us two moving mementoes of Van Gogh on his death-bed—a charcoal drawing and an etching.

Dr Gachet was himself a competent artist with a strong predilection for engraving. There is a drawing in existence by Cézanne in which the artist is shown being given a lesson in engraving by the doctor. At his death his collection of Impressionist pictures was kept intact. The most important paintings such as Renoir's *Portrait of a Model*, Monet's *Chrysanthemums*, Cézanne's *Modern Olympia* and *The House of Dr Gachet*, Pissarro's *Road to Louveciennes*, Sisley's *Saint Martin's Canal*, and Van Gogh's pictures *The Doctor's Portrait*, *Self-portrait* on a turquoise background, and *Auvers Church* were left by Dr Gachet's son Paul to the Louvre.

GAUGUIN Paul (1848 - 1903). Born in Paris; died at Atuana, La Dominique, Marquesas Islands. French painter. A knowledge of the circumstances of his birth, marriage and belated career as a painter is indispensable to a proper understanding of Gauguin and his work. Paul Gauguin was born in the Rue Notre-Dame-de-Lorette in Paris, the son of Clovis Gauguin, a republican journalist from Orléans, and Aline Chazal, daughter of the painter and lithographer André Chazal, and Flora Tristan Moscoso, an eccentric writer and militant socialist. Through his maternal grandmother Flora Tristan, Paul was related to the Borgias of Aragon, who had given several viceroys to Peru. It was therefore quite natural for Clovis Gauguin to think of Peru as a refuge when Louis Napoleon's *coup d'état* forced him to leave France in 1851. He died on the journey. The family continued on its way and went to live in Lima. Aline Gauguin was a loving mother, simple and sweet. (In 1892 Gauguin painted a portrait of her from a photograph and his recollections of her.) After four years in Peru she decided to return to France with her children. Paul was then seven years old. Aline was made welcome in Orléans by Isidore Gauguin, her brother-in-law. Little Paul was sent to a convent school in the town. At the age of seventeen he joined the Navy, just as Baudelaire and Manet had done before him, and visited Rio de Janeiro, Bahia, Sweden and Denmark. After the death of his mother, he gave up the sea and went to work for a Paris Exchange broker. He remained there for twelve years. An intelligent, punctual and methodical clerk, he soon attained an enviable position in the firm. He made money, spent it wisely, and lived in comfort. Eventually he married a young, beautiful Danish girl, Mette Sophie Gad (1873), Evidently Mette, a healthy, practical, steady and not unintelligent woman, thought she was marrying a distinguished man with a brilliant future, capable of bringing her happiness and security. What she wanted, above all, was the peace and pleasure she derived from running her home and supervising the upbringing of her five children. It was not to work out that way. Gauguin struck up a friendship with Schuffenecker, also in the brokerage business, who painted in his leisure time. It was he who introduced Gauguin to painting (1874). His period of apprenticeship was brief and he contributed to the Impressionist exhibitions of

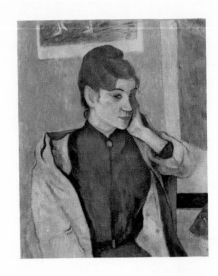

GAUGUIN.
PORTRAIT OF
MADELEINE BERNARD.
1888.
MUSÉE DE GRENOBLE

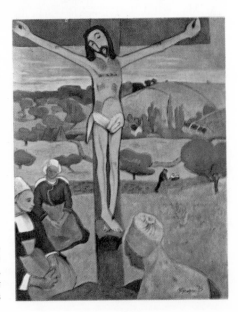

GAUGUIN.
SELF-PORTRAIT WITH
THE YELLOW CHRIST. 1890.
FORMERLY COLLECTION
MAURICE DENIS

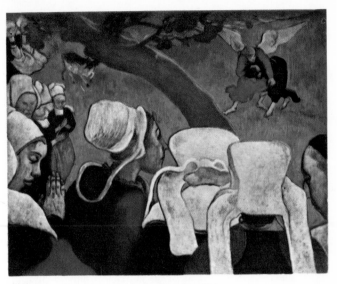

GAUGUIN. THE VISION AFTER THE SERMON. 1888.
NATIONAL GALLERY OF SCOTLAND, EDINBURGH

GAUGUIN. OTAHI (ALONE). 1893. PRIVATE COLLECTION, PARIS

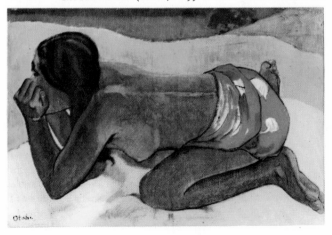

1880, 1881 and 1882. Answering the irresistible call of his vocation, Gauguin gave up his work in 1883 in order to devote himself entirely to painting. Mette was thunderstruck and frightened. From then on, incapable of understanding her husband, or really loving him, she never ceased to give vent to her resentment and deep humiliation, and heap endless acrimonious reproaches, grievances and complaints on his head. Paul Gauguin was free to paint, but he was to suffer till the end of his life. Sick of her husband's 'foolishness', feeling insecure and fearful for the future, Mette decided to take the children and go to live with her parents in Copenhagen. Gauguin went with them. He felt as much a stranger among the Danes as he was to feel at home, later on, among the Polynesians. He took his favourite son, Clovis, and went back to Paris, promising to send for the others as soon as he could (1885). Then began one of the most unhappy periods of his life. Without money, without any hope of making any, he could not even provide for his son. But his passion for painting sustained and stimulated him. He was convinced of his power, his mission, and his genius.

In 1886 he went to live in Pont-Aven, a charming village in Brittany, but stayed for only a few months. Brittany did not give him the stimulus he had hoped for. Old visions, long dormant, reawakened in him. A year later he embarked for Panama with his friend Charles Laval. A typhus epidemic drove them away. They left for Martinique, where the revelation that Gauguin had so long awaited came to him: lush vegetation, ever-clear skies, lavish Nature, and a simple, happy existence. For lack of funds he had to drag himself away from this tropical paradise and return to France (December 1887). Gauguin was then a man of forty, vigorous, domineering, with a noble and haughty bearing. His features are well known, thanks to his numerous self-portraits: the narrow, prominent forehead, the blue, deep-set eyes, the hooked nose and determined chin, the thick neck that suggests heaviness and arrogant power. However difficult his character, however uncompromising his opinions, he could be extremely charming and friendly when he was not contradicted or when those he talked with inspired his confidence.

His was a strong personality, irritating and engaging, in

which the rustic was mixed with the aristocratic, at heart generous and good, despite the legend to the contrary, built up and maintained by the spiteful letters his wife wrote to friends she had left in France. For this husband whom she angrily accused of 'monstrous egotism', this 'unnatural father', never ceased to love his wife and to suffer because he was separated from his children. To get some idea of his real feelings, his humility, tenderness and shyness, one must read his letters. But he was an artist, a man apart, resolved to pursue his destined course regardless of what it might cost him. His social duty counted for nothing in the face of his artistic duty. And, as a result, he made himself suffer as cruelly as those he loved.

Why these various stays in Brittany, Panama and Martinique? As his friend Daniel de Monfreid put it: 'He went to find, in what he believed to be a country of ancient customs, an environment, an atmosphere different from our over-civilized one.' In the Antilles he found the answer to his quest: a paradise setting with clear-cut lines and hard, strong colour contrasts. Gauguin broke with Impressionism, which had hitherto influenced his painting (1887). On his return to France he expressed his disapproval of Monet's and Pissarro's naturalist fiction. He formulated and preached 'Synthesism'. It may well be that the aesthetic principles designated under this name were inspired by Émile Bernard, as Bernard claimed. Bu that does not matter, for it was Gauguin who first enunciated this new theory and practised it with supreme mastery. Massive, simplified forms, flat colours, cloisonnism, shadowless drawing, abstraction of design and colour, free treatment of Nature—such were the principal articles of the credo that Gauguin formulated in 1888 during his second stay at Pont-Aven, and completed in the same year at Arles (where Van Gogh revealed Japanese art to him), and at Pont-Aven and Le Pouldu (from April 1889 to November 1890). It was at this time that he painted *The Vision after the Sermon* (1888) and *The Yellow Christ* (1889). He also tried mural painting, sculpture, engraving and ceramics.

His ancestry, his childhood memories, the impressions he brought back from Martinique, his three stays in Brittany—all these gave him the incentive to renew an art that had been corrupted by the Impressionists. Eight painters grouped themselves around him, and constituted the School of Pont-Aven.

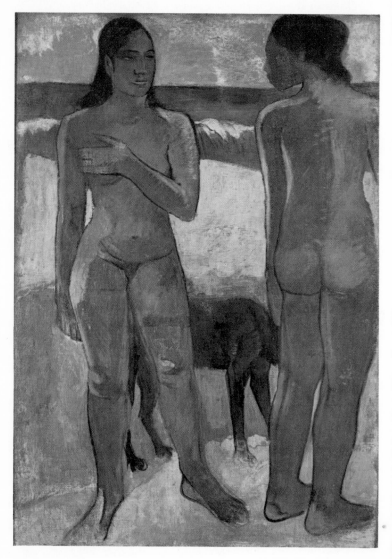

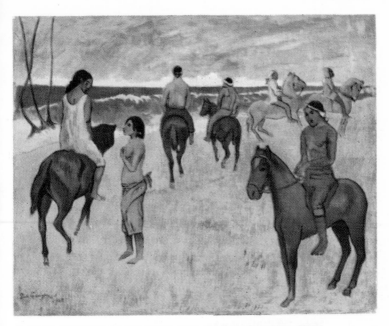

GAUGUIN. HORSEMEN ON THE BEACH. 1902. FOLKWANG MUSEUM, ESSEN

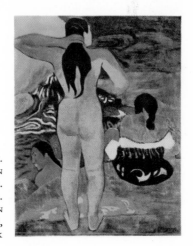

GAUGUIN.
TAHITIAN WOMEN
ON THE BEACH.
1891-92.
ROBERT LEHMAN
COLLECTION,
NEW YORK

Led by Sérusier, the Nabis came and joined them. Fêted in Paris by the independent critics, by writers such as Stéphane Mallarmé, the poet, and Octave Mirbeau, the novelist, Gauguin might well have been content with such a strong position. But in the midst of his court he began to feel more and more alone. Brittany had nothing more to offer him, and France was too small for him and his dream. On the 23rd February, 1891, he put thirty of his paintings up at auction, and with the proceeds embarked for Tahiti on the 4th of April.

At Papeete he found Europe again, with its vices, its stupidity and its frivolity. He went to live in Mataiéa, in a straw hut, among the peaceful, ingenuous population. He joined in all their rites and games, determined to destroy whatever trace of 'civilization' still remained in him. When his money ran out, and his debtors in Paris ignored his requests for payment, he .was left without food, without clothes, and completely debilitated by a year of fierce, feverish work. He decided to return to France. *Women on the Beach*, *Vahine with Gardenia*, *Otahi*, *I raro te oviri* (Minneapolis), *When will you marry?*, *Arearea* (Musée de l'Impressionnisme), are a few of the many canvases he painted during this period. When he returned to France, in April 1893, sick, and at the end of his resources, he found a small legacy awaiting him, left by his uncle, Isidore Gauguin. He had several months of happiness. Dividing his time between Pont-Aven, Le Pouldu and Paris, he soon disposed of all his money. In his studio in the Rue Vercingétorix he gave a number of noisy parties, presided over by Annah, the Javanese girl, a monkey and a parrot. The free-spending, easy-going days soon came to an end. An exhibition of his Tahitian works at the Durand-Ruel Gallery on the 4th November 1893, held at the suggestion of Degas, was a fiasco from the financial point of view. But his new painting, mysterious and barbaric, aroused the enthusiasm of Bonnard, Vuillard and all the Nabis. After a series of misfortunes (including a last, painful interview with his wife in Copenhagen, and the flight of Annah, who ransacked his studio), Gauguin decided to return to the South Seas. A second auction to finance him was a complete failure. He set out nevertheless, for Tahiti, and arrived there in July, 1895. He settled in the north of the island, and set to work immediately. And that is how the legend began, so common

today, so unusual then: the legend of the European casting off civilization, alone and naked before the splendour of Nature. In October Gauguin began to have severe physical suffering. Whenever it abated, he applied himself to his work with renewed ardour and frenzy. The year 1897 was one of great sorrow for him: his beloved daughter, Aline, died; his correspondence with Mette came to an end; he was in hospital for a time. But it was also the year of his masterpieces *Whence Come We? What Are We? Whither Do We Go?* (Museum of Fine Arts, Boston), *Nevermore* (Courtauld Institute, London). His manuscript *Noa Noa* appeared in the *Revue Blanche*. The following year, after an attempt to commit suicide, he went to work as clerk and draughtsman in the Department of Public Works. Sick at heart, suffering from the effects of syphilis, he nevertheless had the courage to paint, draw, sculpt, engrave and write. He got himself into trouble defending natives from rough handling by the whites. He was even sentenced to three months' imprisonment and a fine of a thousand francs. Finally, worn out by privations, almost unable to move, he died on the 6th May, 1903, after executing some of his finest canvases: *Barbaric Tales*, *Horsemen on the Beach* and *The Gold of their Bodies* (Musée de l'Impressionnisme). The last thing he painted was a Brittany snow scene.

What Gauguin went to find in the South Seas was original purity, innocence, a way of forgetting oneself, natural man saved from the artificialities of civilization, and the universality and permanence of art. In his desire to reach the source of inspiration he reached the very sources of communication. He attained the solemn grandeur of ancient and primitive art through the immobility of his figures, the impassivity of their features, the serene gravity of their attitudes. That is why he is as close to Cretan and Egyptian art as he is to that of his contemporaries. A creator who wanted to dominate his aesthetic adventure by the intellect, he succeeded in finding the appropriate means for realizing his conceptions. It was in order to give his compositions a monumental and, consequently, decorative character that he deliberately rejected modelling, form values, linear perspective, recession of planes, and secondary details, and neglected movement, relief, and the sensuality of expression. His South Seas canvases inspire a feeling of awe

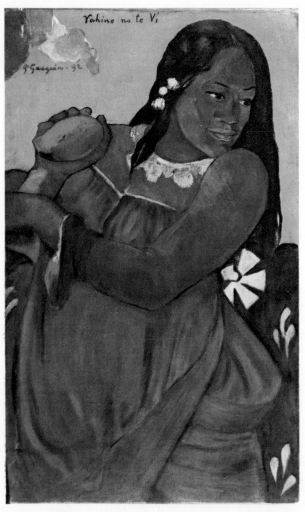

GAUGUIN. VAHINE NO TE VI: WOMAN WITH MANGO. 1892.
CONE COLLECTION, MUSEUM OF ART, BALTIMORE

GAUGUIN. TAHITIAN WOMEN. 1891.
MUSÉE DE L'IMPRESSIONNISME, PARIS

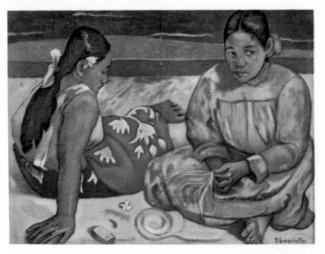

GAUGUIN. AREAREA. 1892.
MUSÉE DE L'IMPRESSIONNISME, PARIS

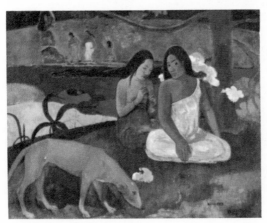

toward life, bitter regret for lost love and liberty, and a fear of the unknown, through the quiet cadence of their lines, their broad, flat areas of colour, and their grave, transfixed sumptuousness. Gauguin excelled in the art of composition. More than that, he invented a composition as different from that of the classical masters as theirs was from the composition characteristic of the Middle Ages. It is true that other precursors have, like him, felt the need to go back to the beginnings of the world, and find again purity of style. But no one was more courageously resolved to do it than Gauguin. 'Barbarism', he said, 'is for me a rejuvenation.' In his search he renewed pictorial art, and gave modern painting a meaning. His companions at Pont-Aven and the Nabis submitted to his leadership, and the Fauves were his direct heirs. Gauguin was also the one who inspired the present interest in ancient civilizations. His sculptures prepared the ground for the acceptance of Negro and Melanesian fetishes. His pagan deities had a genuine air and cannot be dismissed as the products of an aesthetic game. Although whatever he did, his painting remained linked to Western art, it is undeniable that his sculpture derived from quite another vision. It was he who made possible many of the gains and discoveries of contemporary art. Of all the great innovators of the nineteenth century, it is Gauguin whom many non-representational artists of today regard as their precursor.

Like Cézanne, Gauguin lived a spiritual adventure; but, like Van Gogh, he lived a searingly temporal one too.

GOGH Vincent van (1853 - 1890). Born in Groot-Zundert, North Brabant; died in Auvers-sur-Oise. Dutch painter. If, in December 1885, Van Gogh had not experienced a near-blinding revelation as a result of which he produced the masterpieces of the five last years of his life, he would no doubt be hailed today as a great painter of labour and poverty, of workmen and peasants overwhelmed by weariness, the first of the Dutch Expressionists. He became a painter in order to solve an inner conflict by which he was torn, to take his revenge in the domain of art for the failures he had experienced in his life. He was of a Protestant family, a family of clergymen. But two of his uncles were art dealers, a fact that allowed him to start out

in The Hague as a salesman in a gallery recently sold by one of them to the firm of Goupil of Paris. Vincent was sixteen then. Four years later, he was sent by his firm to London, to work in the English branch. In London he fell in love with his landlady's daughter. He asked her hand. He was turned down. Unstable by temperament, acutely nervous, too sincere, he was deeply dejected by this first failure. He left London and went to work at Goupil's head office in Paris, in 1875. He was immediately borne away upon the current of ideas of which Paris was then the centre. He read all the books within his reach, visited museums, underwent the influence of humanitarian writers and of painters concerned with the sufferings of the humble. The Bible became the chief stimulus of this self-taught son of a clergyman. He was dismissed by Goupil in 1876, and went back to England. He worked at a small school at Ramsgate, and then at another, where he did some preaching. He applied for a job as an evangelist among the miners. 'I feel drawn to religion. I want to comfort the humble.' His application was rejected. At Christmas of the same year he returned to Etten, to his parents, but soon there was conflict. From January 21st to April 30th, 1877, he was a clerk in a bookshop in Dordrecht. But he was unable to adjust himself to a practical and regular existence. Therefore, increasingly tormented by his religious calling, he went to Amsterdam to prepare for the entrance examination to the Theological College. After fourteen months of desperately hard work, he had to give up and return to his family. His exasperated father ended by entering him at the Evangelical school at Brussels. In December 1878, Vincent left for the Borinage in Belgium without waiting to be given an appointment. He undertook to bring the miners of this forsaken region back to Christ. He adopted their own poverty, slept on a board in a wooden hut, shared their sufferings, attended the sick, showed the exalted zeal of an apostle, but without success. He was then an ill-clothed, gawky, red-haired fellow, with abrupt gestures and too-bright eyes. His spirit of sacrifice seemed astonishing, his excessive ascetiscism alarming. Men pursued him with sarcasm, children feared him, and as for women—who could love this terrible man ? His superiors got rid of him in July 1879. Then began one of the darkest periods of his life, months of poverty, moral distress, anguish, roving on

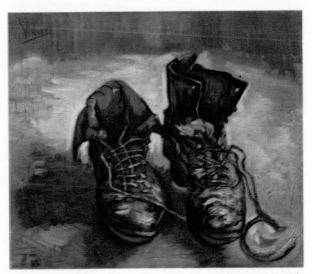

VAN GOGH. BOOTS WITH LACES. 1886.
VAN GOGH MUSEUM, AMSTERDAM

VAN GOGH.
L'ARLÉSIENNE
(M^{me} GINOUX). 1888.
SAM A. LEWISOHN
COLLECTION,
METROPOLITAN MUSEUM
OF ART, NEW YORK

VAN GOGH. FLOWERS IN A VASE. 1887. PRIVATE COLLECTION, GENEVA

the roads. To his brother Theo, who was about to enter Goupil's in Paris, he wrote a poignant letter, in which he announced his decision to devote himself to painting. In October 1880, he was in Brussels, where he studied drawing and made copies from Millet. From April to December 1881, he stayed at Etten with his parents. He experienced another sentimental disappointment there. Turned down by his cousin, Kee, he went away and settled in The Hague. The painter Mauve, another cousin of his, took him in cordially and gave him useful advice. In January 1882, he met in the street a prostitute named Christine, who was ugly, drunk and pregnant. He took her with him. To this woman he gave all the love of which he was capable. The episode lasted twenty months, until he realized definitely that he was no better at individual love than at the love of humanity and the love of God. From then on his humiliated pride took refuge in art. With his artistic apostolate his misfortunes grew. He quarrelled with his father, who disapproved of his artistic career. He fell out with Mauve and Israels, the teachers of The Hague School, whose teaching had finally become unbearable to him. Then, in December 1883, he returned to his father's house, this time at Nuenen, and courageously gave himself up to painting. He did studies of the heath, cottages, weavers, peasants, executed in the rough, black, dismal manner of *The Loom* (1884) and *The Potato-Eaters* (Van Gogh Museum, Amsterdam), his first large picture. His native tendency, the influence of his environment, the contagion of example—all incited him to persevere in this gloomy realism. How, then, can the radiant masterpieces that were to follow be explained?

In November 1885, he was in Antwerp. His father had just died. His brother Theo, with whom he had been in correspondence for five years, had sent him some money. He had discovered Rubens and the joy of life, and also Japanese fabrics, whose colours delighted him. He bought some, decorated his room with them, spent hours contemplating and studying them. He glimpsed an outlet for his still obscure desires, a new world of light, consolation, balance. He decided all of a sudden in February 1887 to leave for Paris. Theo received and sheltered him affectionately. He was dazzled by Impressionist pictures. He met Pissarro, Degas, Gauguin, Signac. In June 1886, he enrolled at the École Nationale des Beaux-Arts in the Cormon

studio, where he made friends with Toulouse-Lautrec and Émile Bernard, who was eighteen then and with whom he kept up a regular correspondence. He worked desperately. He painted streets of Paris, portraits, flowers. He exhibited a few canvases at Père Tanguy's among others by Monet, Guillaumin and Signac. His brother, who was then the manager of the Goupil Gallery, encouraged and backed him. Obsessed by Japanese prints, he copied *The Bridge under Rain* and *The Tree* of Hiroshige. His palette lightened; he even borrowed the Impressionist pointillist technique, as in the *Portrait of Père Tanguy* (1887, Musée Rodin) or in *View from the Artist's Room, rue Lepic* (1887). In the pictures of Pissarro, Monet, Guillaumin, he rediscovered the light handling and the fresh tones of the Japanese. But French Impressionism had caused a decisive shock to his thinking mind. He felt such a need to emulate the Impressionists that he did some two hundred pictures during the twenty months of his stay in Paris. This prolific and sometimes uncontrolled production includes outdoor scenes, such as *Fête at Montmartre* (1886), *Restaurant de la Sirène* (1887), *Gardens on the Butte Montmartre* (1887), still-lifes such as *The Yellow Books (Parisian Novels)* and a series of twenty-three self-portraits, including the one at his easel (1888), which in a way marks the end of this period. The winter of 1887 was an unhappy one for him. The grey sky, the gloomy streets, the sadness of the capital became unbearable to him. The Parisian painters could not give him more than he had taken from them. The rejuvenation he had received from their contact was already exhausted. He needed light, heat, to warm his frozen soul and awaken his eagerness for work. Upon the advice of Toulouse-Lautrec, he went to Arles, on February 20th, 1888. In Provence everything delighted him, the orchards in bloom, the beautiful women of Arles, the Zouaves of the garrison, the drinkers of absinthe. He exclaimed with rapture, 'This is the Orient!' He was thirty-five and felt happy. With ease and enthusiasm he drew with a reed, painted well-balanced canvases, firmly arranged, almost serene. At last he had found clear-cut contours, light without shadow, pure colour, dazzling, crackling vermilion red, Prussian blue, emerald green, sacred yellow, the emblem of the sun. He shed the finery of Impressionism, gave up the divided stroke, fragmented design, subtle modulations. Vigorous,

VAN GOGH. WHEAT FIELD AND CYPRESSES, SAINT-RÉMY. 1889.
COURTAULD INSTITUTE, LONDON

VAN GOGH.
THE MAN WITH
AN EAR CUT OFF.
1889.
LEIGH B. BLOCK
COLLECTION,
CHICAGO

VAN GOGH. AT THE FOOT OF THE ALPILLES. 1890.
RIJKSMUSEUM KRÖLLER-MÜLLER, OTTERLO

VAN GOGH.
LE PONT DE
L'ANGLOIS.
1888.
WILDENSTEIN
COLLECTION,
NEW YORK

precise, incisive, his line captured the inner structure of objects. He painted nearly two hundred pictures in fifteen months, executing three, four and sometimes up to five versions of some of them: *Le Pont de l'Anglois*, *The Plain of la Crau*, *Sunflowers*, *Café at Night*, *L'Arlésienne (Mme Ginoux)*, *The Postman Roulin*, his wife and their son, *Armand Roulin*. From a short stay at Saintes-Maries-de-la-Mer he brought back drawings and canvases, notably his *Boats on the Beach* and a *Seascape* (Moscow). He left an admirable representation of his *Bedroom in Arles* (October 1888), of which he later made, at Saint-Rémy, one replica from memory.

However, his material existence was most precarious. He did not have enough to eat. He sold nothing. He suffered from hallucinations and fits, from which he emerged dazed. The idea of death haunted him. As if he had a presentiment of his approaching end, he hurried, worked furiously, in a state of exaltation that saved him from despair. His mind was on fire. His pictures dripped with golden light. He was 'in the centre of the universal fusion' that transmuted his colours and consumed his brain. Fits grew more numerous. He played with a project for an artists' colony that he would have called 'The Studio of the South', where groups of men would work at projects in common. Late in October 1888, Gauguin responded

VAN GOGH. VINCENT'S BEDROOM IN ARLES. DRAWING. 1888

to his appeal. Vincent was quite cheered up. But in stormy discussions the relationship between these two opposed natures soon deteriorated. On Christmas night, during a futile quarrel, Van Gogh threw his glass in Gauguin's face. The next day, Gauguin, walking in the street, heard hurried steps behind him. He turned and saw Van Gogh with a razor in his hand. Under Gauguin's steady gaze Van Gogh stopped, then fled to his room, cut off an ear with a stroke of the razor, wrapped it in a handkerchief and went to offer it as a present to a girl in a brothel. After two weeks in a hospital he came back to paint the extraordinary *Man with an Ear Cut Off* (January 1889). Meanwhile his hallucinations returned. Neighbours raised a petition for his internment. His unattractive appearance, his touchy character, his whims had alienated people. He had never analyzed his illness more clearly, endured men's hostility with so much resignation, or spoken of his art with more common sense and lucidity, but now he was considered mad. He was sent back to the hospital. In Paris, Theo, who was going to be married, became alarmed and sent the painter Signac to see him. Signac spent the day of March 24th with Vincent, who kept on painting, reading, writing, in spite of his fits. When he felt too ill, he asked to be interned at the asylum of Saint-Rémy-de-Provence, on May 3rd, 1889.

The Arles period was over, the most fruitful if not the most original of his career. During the year he remained at the asylum he produced another hundred and fifty pictures, and hundreds of drawings, working as one possessed, interrupted in his labour by three long fits, followed by painful prostrations. He painted *Yellow Wheat*, *Starry Night*, *Asylum Grounds in Autumn*, a few portraits including that of the *Chief Superintendent of the Asylum*, delirious landscapes, surging mountains, whirling suns, cypresses and olive trees twisted by heat. His colour no longer had the sonority of the preceding period; the yellows had become coppered; the blues darkened, the vermilions browned. In compensation, rhythm became more intense: whirling arabesques, dismantled forms, perspective fleeing toward the horizon in a desperate riot of lines and colours. What he represented then on his canvases he seems to have seen through a vertigo of the imagination. The fire lit by his hand was communicated to his brain. A feeling of failure overwhelmed

VAN GOGH. THE ROAD. 1890. PUSHKIN MUSEUM OF FINE ARTS, MOSCOW

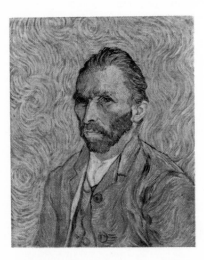

VAN GOGH.
SELF-PORTRAIT.
1890.
MUSÉE DE
L'IMPRESSIONNISME,
PARIS

VAN GOGH.
THE CHURCH
AT AUVERS.
1890.
MUSÉE DE
L'IMPRESSIONNISME,
PARIS

VAN GOGH.
WHEAT FIELD
WITH CROWS.
1890.
VAN GOGH MUSEUM,
AMSTERDAM

him. Could his works be inferior to those of the masters whom he admired? This thought frightened him. In February 1890, he learned of the birth of Theo's son, called Vincent after himself. The generous Theo, so indulgent a brother, at whose expense he, the failure as an artist, the painter incapable of selling a single canvas, had been living so long! Yet, in the *Mercure de France* the critic Aurier had just published the first article devoted to his work. This tribute brought him little comfort. He felt ill, exhausted. Vigilant as ever, Theo asked Doctor Gachet to take Vincent under his care at Auvers-sur-Oise. It was thus that Van Gogh came to Paris, on May 16th, 1890, and settled soon at Auvers. Doctor Gachet attended him, showed him an affectionate friendship, served as a model for him. For Vincent had resumed painting. He did his last self-portrait, *The Church at Auvers* (Musée de l'Impressionnisme), *The Town Hall of Auvers*, the *Portrait of Mlle Ravoux*, that of *Docteur Gachet* (Musée de l'Impressionnisme), and other works, for which he had at his disposal only a technique which had already begun to disintegrate. He feared a new attack of his illness. An unspeakable sadness invaded him. Go on working when the hand refuses to obey, when the enemy within will now always be the stronger? What was the use of trying? That last Sunday in July, Vincent slipped out of the Pension Ravoux, where he was staying. He made for the fields of ripe wheat, where a few days before he had painted the famous *Wheat Field with Crows*. The village was deserted. He stopped in front of a farm. Nobody there. He entered the courtyard, hid behind a dunghill and shot himself in the chest with a pistol. He had the strength to return to the inn, go up to his room and get into bed like a wounded animal. He died two days later, in the presence of Theo, who had hastened to his bedside. He was thirty-seven years and four months old.

Unbalanced, painful, tragic, such was certainly his life. That he suffered from neurosis ánd epilepsy is equally true, but, however impetuously inspired and executed it may be, this art is certainly not that of a madman. Although he put all of himself into his painting, Vincent never abandoned his' very obvious concern for balance, order and reason. His shortcomings are more than offset by an activity which drew from his very failures enough vigour to fight against his

weakness and live in his work. He might have sunk into mental chaos; instead, he triumphed through discipline, work and meditation. In the midst of his greatest discouragements, he retained his love of simplicity and harmony, sought a reconciliation of form and colour, an abstract, coherent transposition of the world. He gave himself an infallible system of principles and rules to reach the artistic ideal that he had glimpsed in his moments of acute insight. Each of his works was the fruit of a thought, a decision, a wish for serenity rather than for strangeness. What did he want? 'Something peaceful and pleasant, realistic and yet painted with emotion; something brief, synthetic, simplified and concentrated, full of calm and of pure harmony, comforting like music.' He tamed his exaltations and his impulses by the laws he had established for himself. Far, then, from being the painting of a madman, Van Gogh's is that of a thoroughly conscious artist and at the same time of a robust man, a dedicated creator. If anything, he saw too clearly. He sought always elements of a beauty of which he could find only an insufficient amount. 'There is an art in the future, and it will be so beautiful, so young! . . .' What bitterness in this cry of hope! He hoped for, prepared, made possible a golden age of painting, knowing nevertheless that he would not see it. More assured of his

VAN GOGH. PROVENÇAL HOUSES BY THE SEA. INK DRAWING. 1888

victories than of profits, it was reserved to him, the discoverer and the pioneer, only to bequeath the means of success to those who came after him. In a way he triumphed over his illness, for his suicide prevented his madness. But he did not create the new art of which he had a presentiment and which he announced with moving certainty in his letters, because the moment for it had perhaps not yet come.

The sureness of his hand equalled that of his will. There is no groping, no working over, nor the slightest alteration in his landscapes or his portraits, which were almost always undertaken directly on canvas, in the manner of the Japanese. 'It is not only by yielding to one's impulses', he wrote, 'that one achieves greatness, but also by patiently filing away the steel wall that separates what one feels from what one is capable of doing.' So Van Gogh expressed the inner duel that eventually exhausted his strength. But if the man died prematurely, the work remains, and contemporary painting was, in a great measure, born of it. Van Gogh appeared when the Naturalist fiction was casting its last glow with Impressionism, at a time when academic conventions were collapsing, when tradition was dying of old age. With Cézanne and Gauguin, he questioned the technique of painting and in doing so prepared for the art of the twentieth century. He used the picture not to imitate appearances or humour the tastes of a cultivated society, but to re-create the world according to his own intelligence and sensibility. While Cézanne was concerned with a new conception of space and Gauguin with composition, Van Gogh emancipated colour, carrying it to its maximum intensity and expressiveness. In his canvases colour reinforces drawing, accentuates form, creates rhythm, defines proportions and depth. It even acquires the value of a sign, addressing itself to the soul as well as to the eye: 'Colour not locally true', he said, 'from the realistic point of view of *trompe-l'œil*, but suggestive of some emotion.' He used it raw, dry, aggressive, in abrupt harmonies, now strident, now muted, without shades, without semitones, with cruel frankness. 'I have tried to express with red and green the terrible human passions', he also wrote. But he always refrained from sacrificing colour to form. And it is right that today his drawings should be admired as much as his pictures. He has left a great number of them, and all of them

VAN GOGH. WOMEN IN THE FIELDS. BLACK CRAYON. 1890

are surprising in their simplicity and acuteness of expression, their assurance and swiftness of line, the variety of the graphic means which the artist used to transcribe on paper the quivering elements of his vision. And this vision was thoroughly his own, of undeniable depth and originality. He has had no direct descendants, although his influence has been felt by all modern painting: Fauves like Vlaminck, Derain, Dufy, Friesz; the Expressionists, in particular Soutine. But Van Gogh was also a poet, a mystic, a thinker. No artist today raises more passionate an interest than he: his painting, his drawings, his correspondence. For Van Gogh lived in advance the drama of our time, a time that 'now liberates and now enslaves'. Nowhere is the study of the artist's correspondence more vital than in the case of Van Gogh. His letters to Theo, in addition to the intrinsic interest they have as deeply moving human documents, are indispensable to a thorough understanding of his concepts and intentions. (*The Complete Letters*, Thames & Hudson, 1958.)

GONZALÈS Éva (1849 - 1883). Born and died in Paris. French painter. She was interested in art at an early age and trained with a fashionable painter called Chaplin. Then she met Manet in 1869, became his model and pupil, and exhibited at

the Salon the following year. She was strongly influenced by Manet and imitated his 'dark' manner for a long time. Her style is more personal in the medium of pastel, which she began using in 1872. In 1874, it was one of her pastels, *The Nest, or Pink Morning*, that the selection committee accepted while rejecting *The Box at the Italian Opera*, an oil painting with a typically Impressionist subject. Both works are now in the Musée de l'Impressionnisme. About 1880, her palette grew lighter and she painted some charming landscapes where the light plays over the leaves and water. She married the engraver Henri Guérard in 1879 and died from an embolism at the age of thirty-four, five days after Manet died.

GUILLAUMIN Armand (1841 - 1927). Born and died in Paris. French painter. As he was first employed in a business firm, then as a civil servant, Guillaumin was a Sunday painter for a long time. He was connected at an early stage with the group of future Impressionists and contributed to most of their exhibitions, notably the famous show at Nadar's in 1874. In 1859, he began attending classes at the Académie Suisse, where he became friendly with Pissarro, Monet and, after 1861, with Cézanne. He exhibited with the third friend at the Salon des Refusés in 1863. Although his subjects are typical of the Impressionists, views of the Seine (*Barges on the Seine at Bercy*, 1871; *Sunset at Ivry*, about 1873, Musée de l'Impressionnisme), snowy landscapes (*Sunken Path*, 1869), and for his fondness for painting on the motive, he stands apart from them through his very personal technique. His brush strokes are broad and vigorous and his colours, reds, violets, and greens, are bright and sometimes even violent, which give vitality to his landscapes and a sort of forthright exuberance. In 1891, when he was at last free from having to earn his living, he travelled in France and abroad, painting wherever he went. Views of the Creuse and the Var, and the coast of Normandy were varied with paintings from Holland, where he spent two months in 1904 in the Zaandam region. They all have his characteristic direct and objective vision: *Snow Thawing in the Creuse* (1898, Modern Art Foundation Oscar Ghez, Geneva), *Dutch View: Sailing Boats* (1904, Musée de l'Impressionnisme). Although he also did a few pastel portraits, Guillaumin was

mainly a landscapist and a faithful fellow-traveller of the Impressionists, but only on the edge of the road, so that his personal manner led him to the threshold of Fauvism.

JONGKIND Johan Barthold (1819 - 1891). Born in Latrop, Holland; died in Grenoble. Dutch painter. Jongkind divided his life between work and dissipation, art and vice, heaven and hell. Isabey, who often helped him, discovered him, brought him to Paris in 1846, and showed him how exciting the Channel coasts could be for a painter. He brought back drawings, paintings and watercolours from these visits to Normandy in which he had caught the play of light on water, in expanses of sky, and through the leaves and branches of trees, long before Monet and his friends attempted similar effects. He exhibited at the Salon des Refusés in 1863, but success came to him between 1865 and 1870. Jongkind was a precursor of Impressionism in his painting of the ephemeral atmosphere and changing, shifting nature. The work he did for a middle class public was carefully finished, but his watercolours, which are technically excellent, are more original (*Sunset over the Meuse*, about 1866, G. Signac Collection, Paris).

JONGKIND. SUNSET. ANTWERP HARBOUR. 1868. ETCHING

JONGKIND. THE BEACH AT SAINTE-ADRESSE. 1863.
MUSÉE DE L'IMPRESSIONNISME, PARIS

GUILLAUMIN. SNOW THAWING IN THE CREUSE. 1892.
MODERN ART FOUNDATION OSCAR GHEZ, GENEVA

His delicate, clear, serene art is a strange contrast to his turbulent life. He gave up his disastrous habits for a while under the affectionate influence of his Dutch companion. In 1878, they went to live at La Côte-Saint-André, but he took to drink again there and his career ended wretchedly. He was sent to the lunatic asylum at Grenoble and died there on 9 February 1891.

MANET Édouard (1832 - 1883). Born and died in Paris. French painter. Manet belonged to the upper middle class, and his existence was bound to that class; he remained attached to the privileges it enjoys, wished to receive the honours and recognition it confers, and at the same time gave rise during his lifetime to the most violent scandals and unwittingly produced through his painting a complete revolution. He brought a taste for liberty that did correspond to the aspirations of the time but was not yet admitted in its consequences. Academic art was still dominated by what was thought to be a tradition but in fact consisted of no more than the impoverished remnants of superannuated formulae. At the beginning Manet probably had no intention of playing the part of a revolutionary leader. He had very prudently begun by setting out upon a more conventional career. Yielding to family insistence, he started out in 1848 as a student pilot on a training ship, and made the voyage to South America. When he returned, he failed his examination at the Naval School and at last succeeded in persuading his father to let him become a painter. In January 1850, he joined the studio of Thomas Couture. His independence brought him into immediate conflict with his teacher. He did not, however, approach the profession with preconceived ideas, sure of inventing a personal technique. He frequented the Louvre very assiduously, his lessons left him unsatisfied, and the example of masterpieces convinced him that he had more to learn from the masters and from Nature. His character as a painter therefore derived from his stays in Fontainebleau and from his admiration for Tintoretto, Titian and Velasquez. In his first works, already stamped by these influences, an inclination can be discerned for clear colours, a free touch, and large, vibrant flat areas. His visits to Holland, Germany and Italy reinforced this tendency, in which he was reviving the

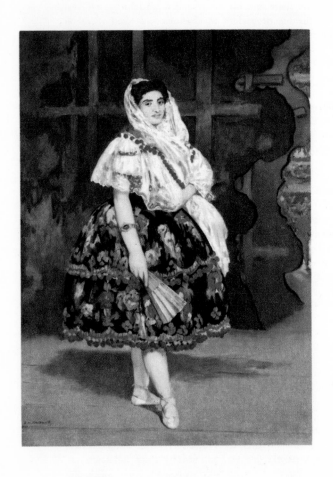

MANET. LOLA OF VALENCIA. 1861-62.
MUSÉE DE L'IMPRESSIONNISME, PARIS

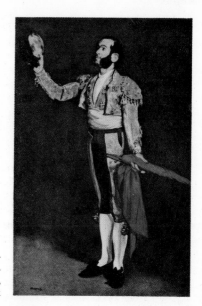

MANET.
TORERO SALUTING. 1866.
METROPOLITAN MUSEUM OF ART,
NEW YORK

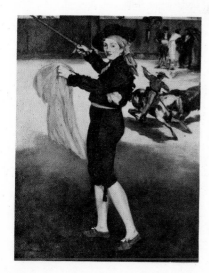

MANET.
MADEMOISELLE
VICTORINE
IN THE COSTUME
OF AN ESPADA.
1862.
METROPOLITAN
MUSEUM OF ART,
NEW YORK

99

freedom and dash of Frans Hals and the Venetians of the Renaissance. His *Portrait of a Spanish Musician* won an 'honourable mention' at the Salon of 1861 and, because of the subject, also earned the praises of Théophile Gautier. The following year, a show given by a troupe of Spanish singers and dancers made him all the more enthusiastic about Spain and inspired a whole series of paintings. The famous *Lola of Valencia*, which Baudelaire called a 'jewel in pink and black', was one of them. The affinities between Manet's art and Spanish painting were once thought so obvious that a critic described Manet as a 'Parisian Spaniard', and Courbet, on the occasion of the 1865 Salon, where *Olympia* was exhibited, said: 'This young fellow had better not try to pull Velasquez over our eyes.' However, it was not until that year that Manet finally went to Spain to see the masters by whom he was supposed to have been influenced. His admiration for Velasquez was strengthened and he discovered Goya.

From the beginning, then, Manet was astonishing and bewildering. The first violent reactions of the public dated from 1863, when he exhibited *Le Déjeuner sur l'Herbe* at the famous Salon des Refusés. The scandalousness attributed to this picture is difficult to understand today. It seemed indecent because it represented a naked woman sitting on the grass between some young men in contemporary dress. At the time nudes were tolerated only in allegorical scenes, when the figures were supposed to represent gods. Actually it is very likely that the technique was even more shocking than the subject. With its freshness and vivacity of colour and its broad execution, the canvas seemed to have been painted on the very spot rather than in the studio. All this indicated on the part of the young artist an inexcusably warped character, an audacity which made him exceed the limits of decency. The rejection of convention, the boldness of the elements employed had at the time an aggressive character, which, in drawing the opprobrium of the righteous bourgeoisie down upon him, made Manet the leader of the young painters. His attitude became even more apparent at the Salon of 1865, where he exhibited *Olympia*. Zola found it the pictorial counterpart of the theories he was himself beginning to elaborate. He felt in the work, in its reaction against accepted standards, a frankness and certainty revealing

an art already liberated and sure of itself, leaving all hesitations and gropings behind it. The public was offended by the presence of a black cat at the foot of the bed, and the Negress offering a bouquet of flowers seemed out of place. The critics, for their part, deplored the lack of shading, the brutality of the drawing, and the crudity of the light, when they did not go so far as to insult. Jules Claretie, very categorical in his denunciations, typified the attitude adopted by the antagonists: 'What is this odalisque with the yellow belly, some indecent model picked up God knows where, presuming to represent Olympia? Olympia? What Olympia? A prostitute, beyond a doubt. M. Manet will never be reproached for idealizing the foolish virgins—he'll drag them all through the mud, more likely.' The model Claretie so grossly insulted was the pretty Victorine Meurend, the central figure of *Le Déjeuner sur l'Herbe* before she became *Olympia* and who was to be *The Fifer* the following year. Today *Olympia* seems to us one of the finest achievements of modern art. In it one admires the unexpectedness of the pose, the firmness and purity of outline, the sincerity of the expression, and the consummate mastery of the composition. Enclosed in its abstract but still living whiteness, seldom has a woman's body known such nudity.

The painters a few years younger than Manet who were soon to create Impressionism did not underestimate the importance of these experiments. They recognized in Manet a precursor behind whom they could gather to renew painting more drastically than the art of a Courbet or a Corot had undertaken to do, much as they admired those painters. Manet benefited in turn from the good feeling of the younger men: having set them the example of his mastery and youthful boldness, he found them, with their glorification of light colour, a stimulus and a new source of inspiration. Although he did not participate in the Impressionist exhibitions organized after 1874, he felt the appeal of this renovation, as his lightened palette testifies. However, he did not become devoted to landscape for its own sake: his outdoor scenes always contained figures, which were the occasion for him to arrange, among the blue and grey reflections with which he surrounded them, dark colours that were set off by the contrast. While he shared with the Impressionists the desire to express sense impressions

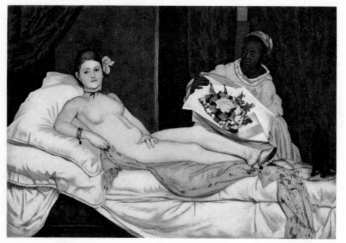

MANET. OLYMPIA. 1863. MUSÉE DE L'IMPRESSIONNISME, PARIS

MANET. STUDY FOR OLYMPIA.
CABINET DES DESSINS, MUSÉE DU LOUVRE, PARIS

MANET. LE DÉJEUNER SUR L'HERBE. 1863.
MUSÉE DE L'IMPRESSIONNISME, PARIS

in all their immediacy, he never resorted to the systematic breakdown of colour. Unlike his young friends, he had no horror of black—quite the opposite. Black was to him, as to Frans Hals, a real colour, which he often used, and which gave an extraordinary brightness to many of his compositions. Neither was he haunted by plastic problems like Cézanne, or obsessed with drawing like Degas. Manet did not attempt to set up a system: less a theoretician than a painter, instinctively inspired and gifted, he wanted, above all, to re-create on canvas the vividness and intensity of what he experienced. No doubt he was always surprised by the scorn he encountered in academic circles. For a long time he persisted in exhibiting at the Salon and ended by being awarded a secondary medal that put him out of the running. But this was in 1881, and his career was already fulfilled—so much so, in fact, that the next year he was made Chevalier of the Legion of Honour (through the intervention of Antonin Proust, his fellow student at the Collège Rollin, who had by then become Minister of Fine Arts).

The art of Manet is an introduction to the future, in its freedom of handling and the importance bestowed on colour. Even when he applied the pigments flat and refused to tone them down, his colour retained spatiality, and this was probably his most characteristic contribution to the art of his time. The importance he gave to colour made him sometimes summarize the surface of a volume in a few essential planes and sometimes, on the contrary, adopt broad, uniformly coloured surfaces, as in *The Fifer*. It was in connection with this canvas that Daumier accused him of wanting to reduce painting to the 'faces on playing cards'. This was a failure to recognize the boldness of Manet's experiment; for thus to plant a figure in vivid and brilliantly coloured dress against the emptiness of a mono-chrome background suggested by Velasquez without allowing such extreme simplification to end in a total lack of life, called for the very surest kind of hand. Although every shadow has disappeared and become concentrated in the vibrancy of outline round the form, is it astonishing that this mysterious process has not allowed either the fluidity of outline or solidity of form to diminish. The art of Manet, in spite of its innovations in technique, is nevertheless bound to tradition, because of the influences it has felt, and especially because of the over-all

MANET. WOMAN RESTING. INDIAN INK WASH

concept of a picture that it presupposes. Like the very greatest artists, Manet was able to take a hackneyed theme and give it such life that it seemed new. Without proof, an unsuspecting person would not think of Rubens behind *Le Déjeuner sur l'Herbe* or Titian behind *Olympia*, and yet the relationship is indisputable. *La Pêche (Fishing)* mixes elements found in two works of Rubens: *The Rainbow* and *The Park of the Castle of Steen ;* also from Rubens comes *The Nymph Surprised*, a reversed fragment from *Susanna at the Bath*. *The Dead Torero* is a replica of *The Dead Warrior* of Velasquez, and *The Execution of Maximilian* a pendant to Goya's the *Firing Party, 3rd May 1808.* These are neither imitations nor plagiarism, but real creations starting from an external and independent reality, whether it be an object, a person, or another picture. No matter what theme he selected, Manet fits it to the measure of his own personality. There is no less intensity or life in the canvases inspired by classic works than there is in *The Bar at the Folies-Bergère*, the subject of which was taken from a scene in contemporary life; and this composition conforms to laws no less severe than the others do. Throughout all his changes Manet preserved a surprising unity. No doubt the ability of some men to invent a new vision, so unexpected that it comes as a surprise, and yet so perfectly in accord with still unformulated aspirations that

MANET. THE BAR AT THE FOLIES-BERGÈRE. 1882.
COURTAULD INSTITUTE, LONDON

MANET.
PORTRAIT OF
Mme MICHEL LÉVY.
(PASTEL). 1882.
NATIONAL GALLERY
OF ART,
WASHINGTON

MONET.
ROUEN CATHEDRAL.
1894.
MUSÉE DE ROUEN

MONET.
ROUEN CATHEDRAL,
THE DOOR AND
THE 'TOUR D'ALBANE',
IN FULL SUNLIGHT.
1894.
MUSÉE DE
L'IMPRESSIONNISME,
PARIS

Salon that were not always refused. The first painting he sent, in 1865, was accepted, and even enjoyed some success. Furthermore, he was admitted several times in later years, although of course with more difficulty. In addition to his landscapes, Monet executed a few figure studies at this time, first a large composition, *Le Déjeuner sur l'Herbe*, which he destroyed after it had been criticized by Courbet (an admirable sketch for it survives in the Frankfurt Museum), the *Portrait of Camille*, which attracted much attention at the Salon of 1866, *Women in the Garden* (Musée de l'Impressionnisme) and *Lunch in an Interior*. These canvases, together with a few portraits executed at various periods, are almost the only works in which he gave himself over to the representation of the human figure. This indifference may seem surprising and be regarded as a sign of insensitivity, but a more accurate interpretation suggests that for an artist as scrupulous as Monet–and scrupulousness is characteristic of the Impressionists – the portrait added psychological problems to purely pictorial ones, and that he preferred the more neutral theme of the landscape. Pictorial problems were important enough in themselves for Monet not to want to complicate them still more. He then went through one of the darkest periods of his life. His circumstances became increasingly difficult. His goods were distrained and he saw two hundred of his paintings sold by auction in lots of 50 frs. each. He was twenty-seven years old. In despair, he tried to commit suicide, but his faithful friend, Bazille, helped him to get over his difficulties and failures. Even the work he sent to the Salon of 1869 was refused. The same year, he went with Renoir to Bougival, where together they painted the baths of La Grenouillère. When war broke out, Monet left for Trouville, then for London, where he found Pissarro again, admired Turner's paintings with him and made the acquaintance of Durand-Ruel. Returning to France in 1872, he went to live at Argenteuil, where he made a studio-boat for himself from which he could study at leisure the play of light on water. A suggestion that Bazille had once made came back to him and he invited his friends to form a group and exhibit their work together. They did so in 1874 at Nadar's, but the exhibition – now famous in the history of art – only caused derision and the most malicious comments. To the stiff and static art,

MONET. HAYSTACKS. DRAWING. PRIVATE COLLECTION

manufactured in studios, that was then in favour, Monet opposed a fluidity captured from Nature: not only the fluidity of movement but also that, much more subtle, of environment and atmosphere. Had he been content to seek lifelike postures for figures, like those revealed in a candid photograph, his theories would no doubt have been accepted, but what he wanted to paint was the glow of light, the shimmering of water, the transparency of the atmosphere, the scintillation of foliage. His idea of the instantaneous concerned not forms in motion but an arrest of time: a landscape is not the same at dawn and at twilight, in autumn and in spring. He wanted to paint the sun, the cold, the wind, the mist. These ideas were new and came as a revelation. Oscar Wilde later remarked of him that Nature certainly imitates art, since although nobody before Claude Monet had ever discovered that fog becomes iridescent around the London bridges, nobody could afterwards see London fog without thinking of him.

Thereafter Monet confined himself almost exclusively to landscapes, and mostly to those in which water adds an element of movement. Channel ports, the banks of the Seine, England, Holland, and Venice furnished him with inexhaustible themes

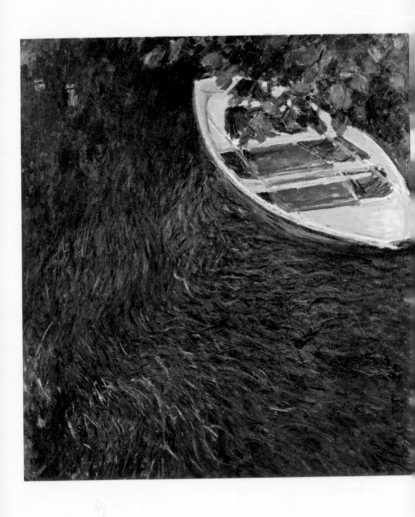

MONET. THE BOAT. ABOUT 1887. MUSÉE MARMOTTAN, PARIS

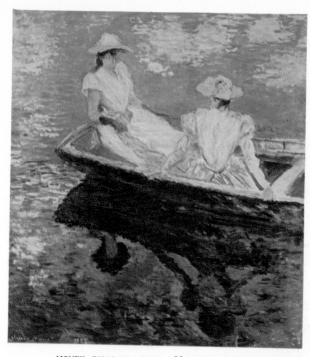

MONET. GIRLS IN A BOAT. 1887. MATSUKATA COLLECTION,
NATIONAL MUSEUM OF WESTERN ART, TOKYO

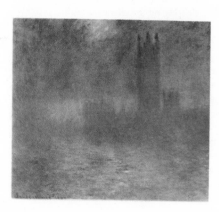

MONET.
THE HOUSES OF
PARLIAMENT: THE SUN
COMING THROUGH FOG.
1904.
MUSÉE DE
L'IMPRESSIONNISME,
PARIS

until his death. Today it is difficult to understand that this art, full of freshness and youth, sensitive to the charm of all seasons, luminous as a song of joy, could have raised storms and brought many years of poverty to its apostle. But his tenacity succeeded in convincing the unbelievers and, about 1880, Monet began to see hostility subside. Calm entered his life little by little and, later, comfort and even wealth with the fame that crowned his old age. However, the crown was not untarnished, for if Alfred Sisley had died too young to see the beginnings of his success, Monet lived to witness the new assaults that triumphant Impressionism was to undergo, this time not from official or academic artists but from the members of the new generation who, making use of the freedom won for them by the Impressionists, rejected them to explore other paths towards other feats of daring, other concepts, even other repudiations. The Impressionist technique, carried to the point Monet finally reached, can undoubtedly be criticized for giving less importance to forms than to the astmosphere enveloping them. But an artist cannot be denied the right to think his thoughts through to the end. Monet was not afraid to seek out this finality. Already in the series of *Rouen Cathedral* one finds no concern for suggesting effects of mass, but only a desire to observe light in all its intensities. It was mainly at Giverny, in the garden that he arranged himself, that Monet achieved his dream in a magic art free of any concern for stable form. His garlands of wistarias, reflected in the shifting mirror of the lake, his sheets of water lilies floating on the changing water, provided him with a whole dazzling play of coloured mirages that were their own justification, like certain variations in music, whose theme is nothing more than a pretext and a place to start. The whole development of Monet's work was toward a complete liberation that allowed him, near the end of his life, to arrive at an art as independent of reality as that of the most abstract painters of today. The astonishing mural ensemble inspired by *Water Lilies*, which occupies two rooms in the Musée de l'Orangerie in Paris, demonstrates the attainment of a poetical world rid of all concern with form, a world in which the evocation of reality is no more than a vague pretext. A curious magic emanates from it, but also the certainty that a point has been reached that cannot be passed, a point where

the artist, at the height of his powers, has discovered a purity beyond which he cannot go without dissolution.

This extreme experiment could not have been attained if Monet had not previously undertaken many times to paint the same landscape seen at different hours, in different seasons, under different lights, with the sole purpose of extracting new effects from the same subject. The views of *The Gare Saint-Lazare* (1876-1877), of *Rouen Cathedral* (1892-1894) and of the garden at Giverny (1905-1908) are among the most celebrated, but there are other sequences, *The Ice Breaking* (1880), *Haystacks* (1891), *Poplars on the Bank of the Epte*, and the views of London and Venice, that deserve being equally known. Those fortunate enough to have seen several canvases on the same theme, assembled and exhibited by the artist at the Durand-Ruel Gallery, realized the interest and appeal of such a grouping. In them Monet demonstrated that no absolute colour exists in Nature, only light; and that since the appearance of all objects changes perpetually, the art of the painter should consist in choosing one moment in preference to any other, in order to fix its individuality in a definitive image. The demonstration is convincing, although Impressionism would have been justified even without it.

It is easy to understand why this art, which at the beginning won the support and encouragement of Naturalists in literature, who regarded it as an illustration of their theories of objective reality, was later disowned by the same writers. It was, in fact, not so much a Naturalist expression that Monet sought as a poetry of suggestions in which imprecision and the absence of clear figures leave a large place for dreaming and a constantly renewed play of colour. Monet's art, as it appears to us today, claims no ancestry in the past, even though some of the painters of the eighteenth century seem to have been its forerunners. One predecessor of Monet can be found in the English painter Turner, although his is an art of pure imagination and magic. The art of Monet, in fact, remains closer to Nature; and if a divergence seems occasionally to exist, the explanation is that the painter's eye has succeeded in catching what previously seemed impossible to seize. He is quite distinct from some of the other painters classified as Impressionists. He has almost nothing in common with the rigorous draughtsmanship of

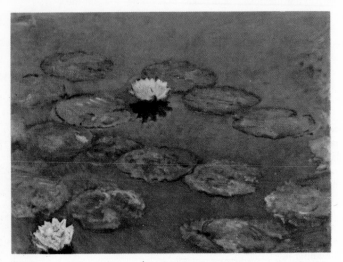

MONET. WATER LILIES. 1920-26. PRIVATE COLLECTION

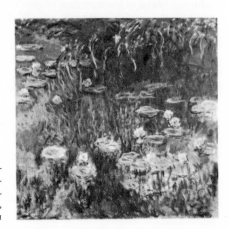

MONET.
WATER LILIES.
ABOUT 1910.
KUNSTHAUS,
ZÜRICH

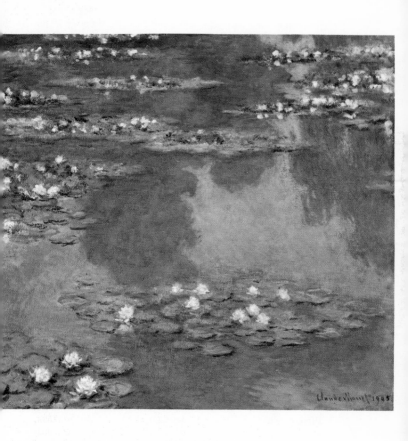

MONET. PAYSAGE D'EAU (WATER LILIES). 1905.
MUSEUM OF FINE ARTS, BOSTON,
GIFT OF EDWARD JACKSON HOLMES

Degas, except when Degas, in later years, indulged, in his pastels and particularly for his dancers, in similar iridescences; his construction was entirely different from Cézanne's, and he had real kinship only with Sisley and Pissarro, although he has more assurance than they. Jongkind and Boudin paved the way for him and succeeded in transcribing similar wet atmospheres in their own manner, but without achieving the poetical quality that remains the unique achievement of Monet.

MORISOT Berthe (1841 - 1895). Born in Bourges; died in Paris. French painter. She came from a cultivated, middle class family and began learning how to paint when she was fifteen. Her first master was a mediocre genre painter, called Chocarne, then a traditionalist from Lyon, Guichard, whose teaching was limited to making her copy old masters. Later, she was a devoted pupil of Corot for six years (1862-8) and this introduced her to painting in the open air. Her early works, like *View of the Little Port of Lorient* (1869, Private collection, New York), which she exhibited at the Salon in 1870, were strongly influenced by her master. Her acquaintance with another painter was an equally important landmark in her career. This was Manet, whom she met in 1868. She became his pupil, his model and, by her marriage in 1874 to his brother, Eugène Manet, his sister-in-law. She now converted Manet in her turn to open-air painting, which was to become an article of faith of the Impressionist group, which she joined from the beginning. Manet's teaching did not replace the earlier influence of Corot but was, in a way, superimposed, and her personal style did not develop till 1879. These converging manners are very noticeable in *The Cradle* (1873, Musée de l'Impressionnisme), which was exhibited at Nadar's in 1874, and in *Maurecourt* (1874, Private collection, Paris). She gradually evolved a very personal technique based on broad brush strokes, freely applied in all directions, which impart a unaffected lightness to her compositions: *Young Woman dressed for a Ball* (about 1879-80, Musée de l'Impressionnisme). When she painted this, she was already moving away from Impressionism, which she considered was too much concerned with rendering the subtleties of atmosphere and, in consequence, neglected form. But she always retained from it a marvellous irisation of light and a delicate, silvery

tone, which give an outstanding quality to her watercolours. They have a delightful spontaneity and there is no doubt that she excelled in the technique: *On the Terrace at Meudon* (1884, Chicago, Art Institute).

NADAR. Pseudonym of the pioneer French photographer Félix Tournachon (1820 - 1910). A friend of painters and writers, he left portraits of both, and these portraits make him a true precursor of modern art. Recalling his own difficult beginnings, as well as those of his friends, Claude Monet once said: 'Nadar, the great Nadar, as good as gold, lent us the place . . .' It is not the least of his glories that the famous photographer lent his studios to the future Impressionists, who organized there (from April 15th to May 15th, 1874) the first of eight exhibitions of the 'Painters, Sculptors and Engravers Company'. It was at this event that the word *Impressionism* was spoken for the first time by a critic who had burst out laughing in front of Monet's canvas *Impression, Sunrise*. Entrance was 1 franc and the catalogue 50 centimes. The entire avant-garde was represented, all the painters rejected by the official Salon. In addition to Boudin, Lépine and some others, who had been invited at the suggestion of Degas, and who were to serve as a sort of guarantee, the future Impressionists, Cézanne included, were present in full strength. Manet alone was absent. Besides the picture previously mentioned, Monet exhibited the *Boulevard des Capucines* and *Boats Leaving the Harbour of Le Havre*. Renoir was represented by, among others, *La Loge*, Berthe Morisot by *The Cradle*, and Cézanne by his *Modern Olympia*, and particularly *The House of the Hanged Man*. Pissarro, Sisley and Guillaumin were present. It was, with Press and public alike, an unprecedented scandal, but 'the good Nadar' was exultant, although he had certainly not suspected the historical importance of his generous gesture. All his life Nadar had the luck and the intelligence to do the right thing. His name will always be inseparable from those of the great artists of his time, of whom he has left unsurpassable portraits. Other than his own *Baudelaire*, no painted portrait has exceeded in psychological interest his feverish *Delacroix*, his disquieting *Constantin Guys*, his Assyrian *Courbet* or his majestic *Monet*. With the same felicity he brought out the cautious finesse of Manet, the

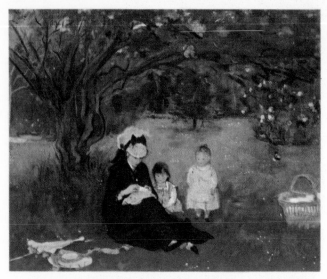

MORISOT. AT MAURECOURT. 1874. PRIVATE COLLECTION, PARIS

MORISOT.
ON THE TERRACE
AT MEUDON.
(WATERCOLOUR).
1884.
ART INSTITUTE,
CHICAGO

sensitive good nature of Corot and the moving melancholy of Daumier. In his attentive search for expression, Nadar always obeyed a strict discipline, which contributed in great measure to the perfection of his results. Thanks to him, photography sometimes equalled painting in the psychological interpretation of characters and faces.

NOUVELLE ATHÈNES. About 1877 the Impressionist painters dispersed. Starting from this period, certain artists, whose names remain none the less linked with Impressionism, began to frequent the Café de la Nouvelle Athènes, in the Place Pigalle. Among them, the writers predominated and included Duranty, Armand Silvestre, Burty, Paul Alexis, Zola's friend, and George Moore, the novelist, who gave a vivid description of the evenings in his *Memoirs*. The only painter who went there fairly regularly was Renoir, who was still living in Paris, Monet and Sisley only put in rare appearances, while Cézanne only went there when his friend, the musician Cabaner, a rather eccentric character, succeeded in taking him along. Manet and Degas were the only ones who used to come fairly regularly. But they were so much out of touch with their Impressionist friends for having kept rather detached from the movement before that they ended by being the only members of the group to frequent the café. It is said that, in one of the rooms of the Nouvelle Athènes, the painter and engraver, Marcellin Desboutin, sat with the actress, Ellen Andrée, for Degas's picture, *Absinthe*, and that Manet did his sketch of the writer, George Moore, sitting at a table in an easy, elegant attitude.

PISSARRO Camille (1830 - 1903). Born in Saint Thomas, West Indies; died in Paris. French painter. Landscapes, particularly the villages of the Ile-de-France, and work in the fields were Pissarro's favourite subjects. He was one of the most typical representatives of the Impressionist group and one of the few who justifies the application of the term 'school' to the movement. He was the eldest of its leading members and took part in all their eight exhibitions. His father, who was Portuguese by birth and a naturalised Frenchman, married a Creole and settled on one of the Virgin Islands, where he had an

ironmongering business. He wanted his son to work with him and sent him to school in Paris. The boarding-school at Passy, where young Camille stayed from 1841 to 1847, was run by an amateur painter, Savary, who taught him to draw and gave him a taste for painting from nature. When he returned to the West Indies, he was convinced after a few years that he was not made for work in his father's trade. In 1852, he caused a sensation by leaving Saint Thomas with a Danish artist, Fritz Melbye, who had been painting with him, and went to Venezuela. His drawings of this period, which are hardly known, already show a promising strength of execution and probably impressed his father sufficiently to let him go to Paris. He arrived there in 1855 when an exceptionally good exhibition of contemporary art was on view at the Exposition Universelle. Delacroix, Millet and Corot especially attracted him and he chose Corot as his artistic mentor. He attended a number of studios, notably the Académie Suisse, where he met Monet, Guillaumin and, in 1861, Cézanne, but he returned frequently to Corot, who gave him permission to call himself Corot's pupil. He inscribed this later on the Salon catalogue instead of his former designation as 'pupil of Anton Melbye', a marine painter and brother of his friend Fritz Melbye, who had given him a few lessons. Pissarro followed the practice of painters he admired and often used to work in the suburbs of Paris. He was admitted for the first time to the Salon in 1859 with a *Landscape at Montmorency*. His work was refused in 1861 and, in 1863, he exhibited at the Salon des Refusés with Manet, Cézanne, Guillaumin and Fantin-Latour. His contributions were sometimes refused later by the Salon. The colour of his painting was rather dark at first, but it gradually lightened and he applied the paint more freely. The influence of Courbet and Manet began to make itself felt and this new approach, which was encouraged by discussions at the Café Guerbois, earned him Corot's disapproval. Pissarro, who had been living at Pontoise since 1866, did several paintings there, which he sometimes succeeded in getting accepted by the Salon with Daubigny's support, but rarely sold and then only for a paltry sum. In 1869, he moved to Louveciennes, which he had to leave the following year because of the Prussian advance. He took refuge in Brittany, then in England, where he met the

picture-dealer Paul Durand-Ruel in London, who took an interest in his painting as he did in all the Impressionists. Monet was in London, too, and went to see the Constables and Turners with Pissarro. Both the English painters contributed in different ways to their personal vision, although the Frenchmen denied this influence later on and tried to belittle its importance. In June 1871, Pissarro returned to France and found his house at Louveciennes looted by the Germans and his pictures destroyed or used as mats in the garden. In 1872, he returned to Pontoise. Cézanne, who was briefly influenced by him, and sometimes Guillaumin came to work with him. Pissarro was the first to realise that Cézanne had exceptional gifts, which the future would soon reveal. His own technique grew freer, between 1872 and 1874, and more 'impressionistic' before the word was coined. The light brushwork and delicate colours reflected his sensitive vision in landscapes that are still among the best he produced: *The Wash-house, Pontoise* and *Approach to the Village of Voisins* (both 1872, Musée de l'Impressionnisme), *The Haystack* (1873, Private collection), *l'Ermitage, Pontoise* (1874, Private collection). Autumn yellow beneath a blue sky and a pale sun shining on a deserted village have a gentle melancholy in these paintings, which Théodore Duret, a great admirer of the painter, called 'an intimate, profound feeling for nature'.

A brief rise in the price of his work corresponded to this development. In 1874, however, he incurred the displeasure of the critics by exhibiting with his friends who, led by Claude Monet, had banded themselves into a 'Cooperative Society of artists, painters, sculptors, engravers, etc.' This first of eight exhibitions organised by the Cooperative Society was immediately taken as an act of defiance towards the official Salon. It marks the historic beginning of the 'Impressionist' movement and earned them the label, which was then derisive. Pissarro contributed five landscapes. The *Charivari* wrote on one of them, *Ploughed Fields*, 'It consists of palette scrapings applied uniformly over a dirty ground.' The collectors were just as aggressive as the critics and Durand-Ruel now had difficulty in selling the large number of paintings he had bought. This did not help poor Pissarro, who now had a sizable family. Three of his sons became painters: Lucien

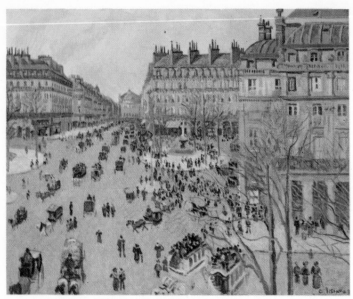

PISSARRO. AVENUE DE L'OPÉRA. 1898. NATIONAL MUSEUM, BELGRADE

PISSARRO. LE CANAL DU LOING. 1902.
MUSÉE DE L'IMPRESSIONNISME, PARIS

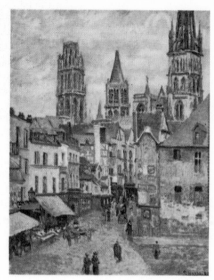

PISSARRO.
RUE DE L'ÉPICERIE,
ROUEN; MORNING,
DULL WEATHER. 1898.
PRIVATE COLLECTION,
PARIS

PISSARRO.
L'ÎLE LACROIX,
ROUEN; FOG EFFECT.
1888.
JOHNSON COLLECTION,
MUSEUM OF ART,
PHILADELPHIA

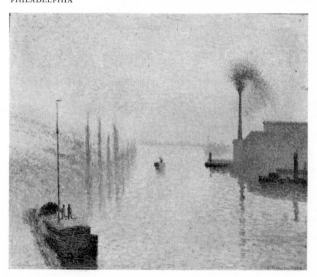

(1863-1941), who was represented at the eighth exhibition; Georges, known as Manzana-Pissarro (1871-1961); and Ludovic Rodolphe, known as Ludovic-Rodo (1878-1952). Camille Pissarro, who had a fighting spirit in spite of his gentle character, never made any concessions to public taste. But he had to contend with overwhelming difficulties and produce easily sold work, like painted fans and prints. He did a large number of prints, more, in fact, than all the other Impressionists, except for Degas. There are more than two hundred of them, mainly etchings and lithographs. The quality is uneven, but some landscapes of Rouen, Pontoise and Eragny, a few country scenes and even some portraits, including his own, show keen powers of observation and an individual technique.

Pissarro's style hardly developed between 1874 and 1886, that is, during the period covering the eight exhibitions of the group. At most, there was an increasing tendency towards rapid, granulated brush strokes, which rather confused colour values and planes. One of the prettiest pictures of this period in its harmony of greens and reds was painted in 1877: *Red Roofs. Corner of a Village, Winter Effect* (Musée de l'Impressionnisme). But Pissarro's colour never had Sisley's refinement and he never approached Monet's experimental audacities nor Renoir's charm. This may have been because he felt the need for a more disciplined technique. When he met Seurat in 1885, he was immediately attracted to the theories that made broken colour the basic principle of neo-Impressionism. From 1886, Pissarro applied these theories to his own painting and he persuaded his reluctant friends to allow Seurat and his follower, Signac, to be represented at their eighth and last exhibition. Pissarro practised Divisionism for two years and the Musée de l'Impressionnisme possesses a characteristic painting of this period: *Woman in an Orchard. Spring Sunshine in a Field at Eragny* (1887). He went to live at Eragny in 1884 after settling in turn at Pontoise, Rouen and Osny. Pissarro's temperament, however, was not suited to the methodical technique of Divisionism. In 1888, he returned to a freer manner, but sometimes he half reverted to using its little juxtaposed dots, notably in the views of Rouen and the boulevards of Paris. In the *Self-portrait* (London, Tate Gallery) of 1903, the year of his death, the face of an old man stares at us with bright eyes. His long

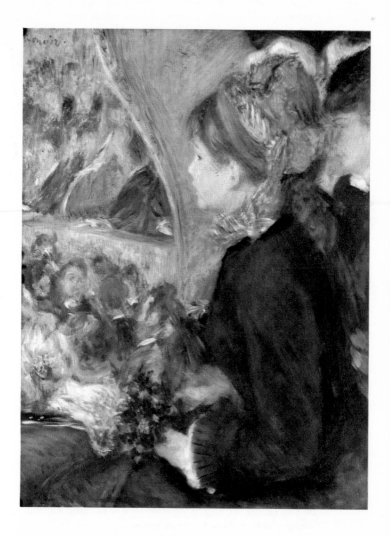

RENOIR. THE FIRST EVENING OUT. ABOUT 1875-78.
TATE GALLERY, LONDON

Impressionist period is that he succeeded in adding a sentimental atmosphere to the representation of Nature and seemed to be just as charmed by a tender interlacing of his figures as by the play of foliage or of water. Although he never yielded entirely to anecdote, it is evident that the subject of the canvas remained infinitely more important for him than for any other painter of the new school. While his friends were chiefly attracted by landscape, his own preference was for group studies and portraits. Having sung the joy of the popular country cafés with music and dancing, he devoted himself to producing some of the most sumptuous images of Parisian society that have been left to us by his period: for example, the portraits of the *Henriot Family* (1876), of *Madame Charpentier and Her Daughter* (1878), of *Jeanne Samary* (1877). A painter of manners, Renoir apparently could not do without the human presence to give measure to his work and express the kind of feeling he wanted to put into it. Whereas Cézanne tended to reduce everything to the impersonal level of the object and to exercise the same calm impartiality for a face as for an apple, Renoir seemed, quite to the contrary, to bring everything into accord with his vision of man. In his work a flower, a fruit are coloured, savoury and palpitating with life, like a human body beneath whose skin one can tell that blood circulates. Cézanne looked and reasoned; Renoir saw and felt. The same opposition is evident in their colour, in the red, or warm, dominants of Renoir, and the blue or green, cold dominants of Cézanne.

But Renoir's Impressionist period proper was approaching its end, and the *Luncheon of the Boating Party*, which he conceived during the summer of 1880, while frequenting the café of Mère Fournaise on the island of Croissy, near Paris, was one of the last canvases in which he was to express and sum up the ideal of his youth in a particularly demonstrative synthesis. He was forty and felt the need for renewal. Nothing troubled him more than the facility, the systematic spirit into which Impressionism threatened to lapse. Renoir, like Cézanne a few years earlier, gained a fresh grip by returning to the classical tradition. He left for Italy in the autumn of 1881. After a stay in Venice, he went on to Rome, where he paused long before the frescoes of Raphael at the Villa Farnèse, and then proceeded to Naples, where he discovered Pompeian painting. Of this period

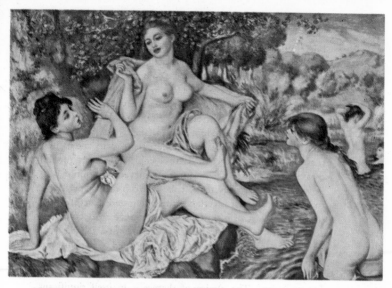

RENOIR. LES GRANDES BAIGNEUSES. 1884-87.
CAROLL S. TYSON COLLECTION, MUSEUM OF ART, PHILADELPHIA

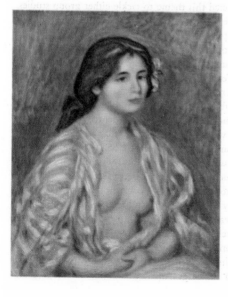

RENOIR.
GABRIELLE IN
AN OPEN BLOUSE.
ABOUT 1910.
PRIVATE COLLECTION

Nudes filled his landscapes to the point of occupying the whole canvas, and red, infinitely modulated, became the dominant colour in which all the others were consumed, in the same way that woman in her eternal youth would be born again every time in Gabrielle, his faithful servant and favourite model. The compositions of this period are unusual in that under the appearance of total freedom they retain infinitely more will than those of Monet or Sisley, but more spontaneity and natural-ness than those of Degas. Here Renoir has given the full measure of himself. These canvases achieved recognition very slowly, and even today many collectors consider them inferior to his earlier ones. It is certain that the big nudes that make up the essential part of his production after 1900 represent, when compared to works like *La Loge* or the *Moulin de la Galette*, an art much more difficult to accept, for, liberated of all constraint, the new manner proved capable of transcribing Renoir's feeling with a boldness that was not yet discernible at the time of Impressionism. The choice of themes is in itself significant. Renoir was not afraid of giving up what had made his success; when his personality was beginning to assert itself in society portraits, he rejected this theme to tackle either group studies, nudes or still-life, with which he could not be sure of con-quering a new public. This attitude resulted more from his character than from an aesthetic doctrine. 'For me', he liked to say, 'a picture must be a pleasant thing, joyous and pretty – yes, pretty! There are too many unpleasant things in life for us to fabricate still more.'

It was inevitable that the physical pleasure in form and texture that Renoir felt to an intense degree and that made him, in his own words, 'pet a picture, stroke it with the hand', should draw him toward sculpture. This he undertook at a time when, unfortunately, physical disability no longer allowed him much suppleness. He secured the assistance of a young sculptor to work under his constant direction. The only sculpture entirely from his own hand is the portrait of his son Coco, which was executed about 1907-1908. Though the later works were done by the sculptor Richard Guino, they were executed under the guidance of Renoir, and they reveal a close relationship of form and spirit with his painting. The large *Venus* and the large *Kneeling Washerwoman* (1917) are

masterful works that can take their place among the master-pieces of contemporary sculpture.

Renoir's is a happy art, for as a man he was without bitterness and without jealousy. His work obeyed an inner logic; it was in harmony with a perfectly balanced life able to accept itself at every moment of its development, even the most painful, when illness had deformed his limbs and in order to continue painting he was forced to have his brush tied to his wrist. The impecunious young man he had been at the beginning, who had lived in Montmartre and met the young women of the quarter, nice working girls, models, with light heads and susceptible hearts, was to be received later in families of the Parisian *haute bourgeoisie*. But, in both cases, whether he painted the ball at the *Moulin de la Galette*, *The Swing*, *Luncheon of the Boating Party*, or executed portraits he had been commissioned to do, it was first his own sensibility that be expressed, more than just the depiction of the sentimental atmosphere of his works, and, needless to say, it was to himself above all that he meant to be true. Thus his emotions as a painter were in harmony with his feeling as a man and, as a result, an exemplary unity was established between his works, in spite of their differences. Neither was there a sharp break when he gave up too specific subjects almost entirely and preferred to paint bathing women with naked torsos in the innumerable portraits of Gabrielle, this being his own way of creating pure painting. For here again it is clear that love of painting and admiration for woman were only the double aspect of a unique passion for living.

SEURAT Georges (1859 - 1891). Born and died in Paris. French painter. He was the founder of Neo-Impressionism and also the leading painter of the movement. His unusual personality was able to evolve an imaginative conception of painting based on technical notions. During his short life he painted less than fifty pictures (he left about two hundred studies also), but he refined the principles of 'optic mixture', or 'Divisionism', to such perfection that we forget the methodical technique as we look at his paintings. This genius made him the leader of one of the strangest schools in the history of painting, the school of Divisionism, or Neo-Impressionism.

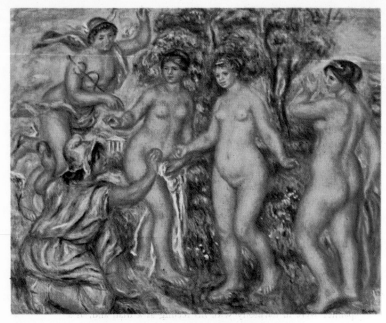

RENOIR. THE JUDGMENT OF PARIS. ABOUT 1914.
HENRY P. McILHENNY COLLECTION, PHILADELPHIA

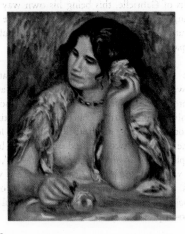

RENOIR.
GABRIELLE WITH
A ROSE. 1911.
MUSÉE DE
L'IMPRESSIONNISME,
PARIS

SEURAT. YOUNG WOMAN POWDERING HERSELF. 1889-90.
COURTAULD INSTITUTE, LONDON

SEURAT.
HONFLEUR;
END OF THE JETTY.
1886.
RIJKSMUSEUM
KRÖLLER-MÜLLER,
OTTERLO

Seurat's life apart from his painting has little interest. Its major activity was his painting and the meticulous, intense pursuit of a technique that satisfied both his orderly, intellectual way of thinking and his love of 'silent' harmonies. The events of his life occupy a few lines only. His father came from Champagne and was a 'huissier' (bailiff) at La Villette, and his mother was a Parisian. He lived with them in the rue de Bondy, now the rue René-Boulanger, and then in the boulevard de Magenta. He moved to Fontainebleau during the Commune, did his military service at Brest in 1879, which his period as a volunteer reduced from five to one year, then made his home in Paris in 1880 at 19, rue de Chabrol. He spent the summers of 1885 at Grandcamp and of 1886 at Honfleur. In 1888, he visited Brussels with Signac and stayed at Port-en-Bessin. In 1889, he worked during the summer in Le Crotoy. His son, Pierre-Georges, was born on 16 February 1890. The mother, Madeleine Knobloch, sat the same year for his painting, *Young Woman Powdering Herself* (London, Courtauld Institute). He spent the summer at Gravelines. The following year, on 29 March, he died of diphtheria at the age of thirty-two. His child died of the same disease fifteen days later. It was against the background of this uneventful life, that some of the masterpieces of French painting were produced in a space of ten years.

In 1875, when he was very young, he left his school for the École Municipale de Dessin in the rue des Petits-Hôtels, where he attended the classes of the sculptor Justin Lequien, a pupil of Bosio. He met Aman-Jean there, whose fine portrait drawing he made in 1883, which was the first work he sent to the Salon and the only one ever to be accepted. In 1877, he worked in the galleries of the École des Beaux-Arts, making meticulous drawings of plaster casts of classical statues and preparing for the competitive entrance examination. He joined the studio of Henri Lehmann, an academician and pupil of Ingres. He also studied the old masters in the Louvre, but he discovered his real masters in 1879 at the fourth exhibition of the Impressionists. Renoir and Sisley were not represented that year, but Degas, Pissarro, Gauguin, Lebourg and especially Monet came as a shock of surprise to him. Not long after, he was convinced of the futility of Beaux-Arts teaching and he left the 'École' with Aman-Jean. They rented a studio together at 32, rue de

l'Arbalète. It was not so much a particular kind of painting that provided the immediate stimulus for Seurat to discover his extraordinary mode of expression so much as his reading of some books on optics, which fascinated him. The first was Charles Blanc's *Grammaire des Arts du Dessin*, published in 1867, in which the writer tried to show how 'colour, analysed according to reliable laws, could be taught like music'. The second was an older but more technical book, *De la loi du contraste simultané des couleurs* (1839) by Eugène Chevreul, in which the theory of complementaries opened a range of ideas to Seurat that he felt would be the key to his aesthetic investigations. After this, he read every book on colour that he could lay his hands on, including the works of Charles Henry, Maxwell and Helmholtz. He also read David Sutter's *les Phénomènes de la vision*, published in the review *l'Art* in 1880, and *Théorie scientifique des couleurs* by Ogden N. Rood, published in 1881. It may have been the last book that convinced him of how a thorough understanding of colour was impossible without mastering the art of drawing. Rood wrote, 'If an artist does not have a complete grasp of the art of drawing objects with light and shadow, he will gain nothing from trying to grapple with the problems of colour.' Shadow and light were the characteristic elements of Seurat's work. After drawing at the beginning of his career with Ingresque assiduousness, he began to evolve his personal technique. He found it in 1881. The result was an admirable collection of about 400 drawings, in which individual lines have disappeared in favour of velvety forms molded by rubbing soft Conté pencil on coarse grained Ingres paper. All volume is suggested by light and dark masses of shading; the final effect is of a sort of black and white painting. The subtleties of half-light and concealed light play over portraits, including his mother's, silhouettes of peasants at work in which Millet's influence is evident, suburban townscapes and studies to decide the value and positioning of all the figures that he eventually put into his large paintings: saunterers along the banks of the Seine, studio models, café-concert singers, acrobats and so on.

Une baignade, Asnières (London, Tate Gallery) was his first large picture in which the rhythm was strongly pronounced but the paint was still handled in an Impressionist manner rather

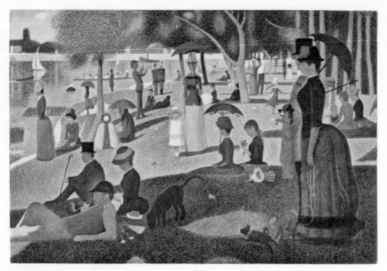

SEURAT. SUNDAY AFTERNOON AT THE ÎLE DE LA GRANDE JATTE. 1886.
ART INSTITUTE, CHICAGO

SEURAT. UNE BAIGNADE, ASNIÈRES. 1883-84.
NATIONAL GALLERY, LONDON

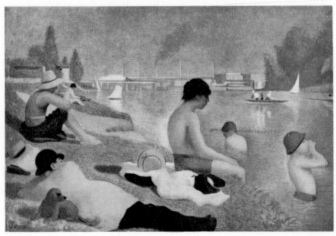

SEURAT. LOWER CROTOY. 1889. NIARCHOS COLLECTION, ATHENS

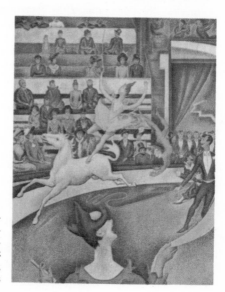

SEURAT.
THE CIRCUS.
1890-91.
MUSÉE DE
L'IMPRESSIONNISME,
PARIS

than according to strict Divisionist principles. The selection committee refused it for the Salon of 1884. It was to fight against injustices like this that the Société des Artistes Indépendants was founded the same year and Seurat exhibited regularly at its annual Salon. The *Baignade* was shown in the first one. He began working immediately afterwards on preliminary studies for a larger painting, which included thirty-one pochades and twenty-three drawings. It was completed in 1886 and was hung, with five other paintings, in the eighth and last Impressionist exhibition. This was *Sunday Afternoon at the Ile de la Grande Jatte* (Chicago, Art Institute). This time, to the astonishment of a number of the visitors, he applied the technique of 'optical mixture', which consists in placing dots of colour side by side on the canvas, instead of mixing them on the palette, and the eye blends them in the act of perception. Critics and public were almost unanimous in their condemnation but Seurat found a fervent defender in Félix Fénéon, who remained the most devoted critic of his work. He noticed the hieratic aspect of the *Grande Jatte*. It was the first time Seurat had carried his theory to final consistency, and his systematization gave his figures this strange appearance. Then he tried to communicate the sadness or gaiety of a figure – one mood was not very different from the other – through the graphic idiom of every form. Seurat's style was as distinctive in the draughtsmanship of his compositions as in his colour, but it was the principle of Divisionism that attracted painters like Pissarro and Signac. He gradually perfected it from one painting to the next and every subject he handled turned out a masterpiece. The *Grande Jatte* was a sort of fresco of Sunday leisure, where about forty people, three dogs and a monkey are skilfully arranged beneath the trees on a bank of the Seine. His next work was *View of a Dock at Honfleur* (Otterlo, Rijksmuseum Kröller-Müller), which he painted on the quayside in 1888, arranging the lines of the quays, masts and ropes into an unusual composition of verticals, horizontals and diagonals. In 1887, he did three figure studies, front, back and side view (Musée de l'Impressionnisme), which he used in 1888 for the *Models* (Merion, Philadelphia, Barnes Foundation). He also painted the same year *Outer Harbour, Low Tide* (Saint Louis, Missouri, City Art Museum), which is the quintessence of

noonday silence in the purity of the summer light. The most famous of the year's pictures is *La Parade* (New York, Metropolitan Museum of Art) in which the musicians and the ringmaster of a travelling circus are painted in an artificial light with carefully studied forms and a subtle harmony of ochres and violets. A new series of landscapes began in 1889 with *Le Crotoy, Seaside* (Coll. Stavros Niarchos, Athens) and in 1890 with *The Channel at Gravelines, Little Fort Philippe* (Indianapolis, Indiana, The John Herron Art Institute), which is among the finest examples of Divisionist painting. Again in 1890, he produced two paintings with the arabesques of the Art Nouveau of contemporary decoration : *Le Chahut* (Otterlo, Rijksmuseum Kröller-Müller) and *The Circus* (Musée de l'Impressionnisme), which was left unfinished at Seurat's death.

SIGNAC Paul (1863 - 1935). Born and died in Paris. French painter. Signac was one of the first to adopt neo-Impressionism and was also the theoretical writer of the movement. He was a man of action as well as an intellectual and enjoyed sailing as a relaxation of his occupations as journalist and writer. He had a warm-hearted nature and encouraged young painters when he was president of the Société des Artistes Indépendants from 1908 to his death. He had a middle class background and his parents kept a saddler's shop in the passage des Panoramas. They sent him to the Collège Rollin and nothing suggested that he would become a painter. In 1880, the Monet exhibition impressed him deeply. Painting in the open air was what he wanted to do and he began the next year on the banks of the Seine. It was natural that his early paintings should be influenced by Monet; he visited him and later on became his friend. In spite of this, in 1883 he joined the studio of a former winner of the Prix de Rome, Bin, for his preliminary training. However, Monet's influence persisted and the four landscapes he exhibited at the first Salon des Indépendants in 1884 were Impressionist. They were views of the Paris suburbs and of Port-en-Bessin, where he had spent the summers since 1882 and where he took Seurat. Their meeting in 1884 was a landmark in Signac's career and his artistic ideas. He was wholly converted to Divisionism and became the most energetic member of the movement. At the eighth and last Impressionist exhibition

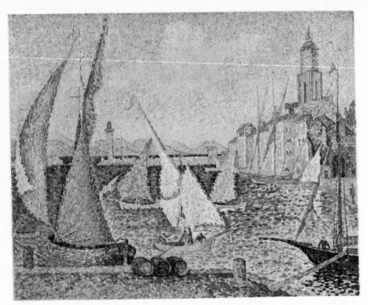

SIGNAC. THE PORT AT SAINT-TROPEZ. 1894.
MUSÉE DE L'ANNONCIADE, SAINT-TROPEZ

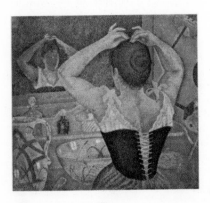

SIGNAC.
WOMAN DOING
HER HAIR. 1892.
M^{me} G. SIGNAC
COLLECTION,
PARIS

SISLEY. BOAT DURING A FLOOD. 1876.
MUSÉE DE L'IMPRESSIONNISME, PARIS

SISLEY.
SNOW AT
LOUVECIENNES.
1878.
MUSÉE DE
L'IMPRESSIONNISME,
PARIS

in 1886, he showed his first Divisionist paintings, including the *Road to Pontoise* (Leeds, City Art Gallery), which were all done that year. He never changed his technique and even used it for interiors, which are rare in his work: *Breakfast* (1887, Otterlo, Rijksmuseum Kröller-Müller) and *Sunday in Paris* (1888/90, Private collection). A great many of Signac's works are views of the sea, its shores and ports, which reflected his passion for boats. He had thirty-two during his life, including the canoe, called *le Hareng saur épileptique*, on which he took Seurat for a trip on the Seine. His yachts were moored at Saint-Tropez, where he went for the first time in 1892 and used to offer such a warm welcome to his friends at his house 'La Hune'. It was there in 1904 that Matisse, who was briefly half converted to neo-Impressionism, painted the most typical example of the style, *Luxe, calme et volupté* (Coll. Mme Ginette Signac, Paris). The titles of some of Signac's works are landmarks in his travels. *Les Balises, Saint-Briac* (1885, Private collection), *The Lighthouse at Pontrieux* (1888, Otterlo, Rijksmuseum Kröller-Müller) and *Fishing-boats at Concarneau* (1891, Coll. Robert Lehman, New York) were all painted in Brittany. The Mediterranean coast is the subject of *The Port at Collioure* (1887, Otterlo, Rijksmuseum Kröller-Müller), *The Port at Saint-Tropez* (1892, Wuppertal, Von der Heydt Museum), *The Port of Marseilles* (1897, Otterlo, Rijksmuseum Kröller-Müller) and *Evening at Antibes* (1914, Strasbourg Museum). He painted pure marinescapes at La Rochelle between 1911 and 1932, Venice in 1904, Rotterdam in 1906, Constantinople in 1907 and Corsica in 1932. His style over the years moved, at first, towards a brighter colour range, then, from 1896, towards a freer sense of form and a looser brushwork. His watercolours always had this freedom. He painted a great number and their rapid, impetuous brushwork is similar to Jongkind's manner, on whom he wrote a book in 1927. Some parts of his *Diary* are very lively and in 1899 he published an important book on the history of 'optical mixture', *D'Eugène Delacroix au Néo-Impressionnisme*.

SISLEY Alfred (1839 - 1899). Born in Paris; died at Moret-sur-Loing. Although he lived nearly all his life in France, he retained his British nationality. Sisley and Monet are the two

great landscapists of the Impressionist group, but he only exhibited four times at their shows, in 1874, 1876, 1877 and 1882. He painted the roads, rivers and skies of the Ile-de-France with a subtlety of colour that reflected an exceptionally sensitive vision. Sisley's parents lived in France and planned a business career for their son. In 1857, he was sent to England for four years but, on his return to Paris, he had other ideas and, in 1862, joined the École des Beaux-Arts in Gleyre's studio, the history painter, whose works include *Les Illusions perdues* and *Hercules and Omphale*. He made the acquaintance there of Monet, Renoir and Bazille. Like them, he found the limitations of the academic teaching irksome and they soon left the school with Monet. The following year, all four left Gleyre's studio. They went to work on the banks of the Seine and in the country round Fontainebleau, at Chailly-en-Bière, where Monet painted his *Déjeuner sur l'herbe*, one of the early Impressionist paintings, and at Marlotte, where Renoir joined him to paint in 1865. Both of them sailed down the Seine to Le Havre. In 1866, two of Sisley's paintings were accepted at the Salon but his work was subsequently refused every other year. His early work was influenced by Courbet, Daubigny and sometimes Corot, like *View of Montmartre* (1869, Grenoble Museum). It was Monet who helped him find his real way. In 1871, he left France for England. His parents were ruined and his financial difficulties were beginning. He often suffered dire poverty to the end of his life. His style began to mature about 1872 and he became one of the most attractive landscapists of his time. In the many places he set up his easel, Argenteuil, Bougival, Louveciennes, England in 1874, later on at Sèvres, Veneux-Nadon where he lived in 1879, Moret-sur-Loing where he moved in 1882, Saint-Mammès in 1883, and again at Moret where he lived till his death, he seized the delicate harmonies of nature and handled them with a lightness of brush and a variety of tones that made him one of the subtlest painters of spring and autumn light and the play of clouds over water, where the blue is tinged with pink in a reciprocated tonality between sky and river.

His work is well represented at the Musée de l'Impressionnisme, which possesses some of his finest landscapes among about thirty in its collection: *The Canal* (1872); *The Road,*

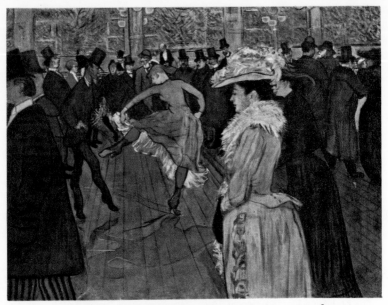

TOULOUSE-LAUTREC. AT THE MOULIN-ROUGE: THE DANCE. 1890.
HENRY P. McILHENNY COLLECTION, PHILADELPHIA

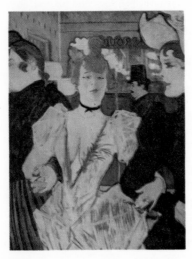

TOULOUSE-LAUTREC.
LA GOULUE ENTERING
THE MOULIN-ROUGE.
1892.
DAVID M. LEVY
COLLECTION,
NEW YORK

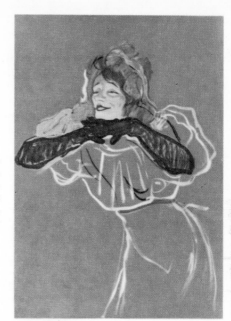

TOULOUSE-LAUTREC.
YVETTE GUILBERT.
1894.
PUSHKIN MUSEUM
OF FINE ARTS,
MOSCOW

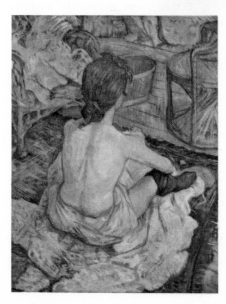

TOULOUSE-LAUTREC.
LA TOILETTE. 1896.
MUSÉE DE
L'IMPRESSIONNISME,
PARIS

View on the Way to Sèvres (1873); two views of Port-Marly painted in 1876, *Boat during a Flood* and *Flood at Port-Marly; Snow at Louveciennes* (1878); *Saint-Mammès* (1885); *The Loing Canal* (1892). From 1890, he exhibited regularly at the Salon de la Société Nationale des Beaux-Arts. His first one-man exhibition was held at Durand-Ruel's in 1883 and was followed by two others: in 1893, at Boussòd-Valadon's and, in 1897, at Georges Petit's. When he died of a throat cancer in his home in the rue du Château at Moret, he had still not enjoyed real success. The price of his paintings rose after his death but fame came much later.

TANGUY Julien (1825 - 1894). Père Tanguy started his career in art as a dealer in artists materials in the rue Clauzel, in Montmartre. In 1870 he decided to add the sale of the works of his painter friends to that of his regular stock. He bought Van Goghs but never sold a single one of them. He was not disheartened, though, and moved by an unyielding faith, continued to pile up canvases by Monet, Sisley, Cézanne, Gauguin and Seurat. Tanguy visited the painters in their studios at Moret and Pontoise, bringing them paints (payment for which was generally long deferred), and he haunted the Salons. It was at his place that Vollard discovered Cézanne, and it is interesting to note that, from 1877 to 1893, his shop was the only place in Paris where Cézanne's canvases could be seen. He unfailingly backed the efforts of his friends, in spite of the fact that his means were always modest, and it was to him that many painters owed, at certain critical moments, their ability to continue working.

TOULOUSE-LAUTREC Henri de (1864 - 1901). Born in Albi; died at the Château de Malromé, Gironde. French painter. He was outstanding among the artists who were too young to have belonged to the Impressionists but were influenced by them at the outset of their careers. If Impressionism had not brought such freedom in the use of colour, his own work would not have gone so far, yet its originality does not lie in landscape but in a form of expression where drawing is more important than colour.

He was descended through his father, the Comte Alphonse

de Toulouse-Lautrec Monfa, who had married his cousin, Adèle Tapié de Celeyran, from the counts of Toulouse, who had been partly defenders of the Albigensian Cathari. He spent his youth in the old family residences in the country and very soon discovered he had a taste for drawing. After a rather brief spell at the Lycée Fontanes, now the Lycée Condorcet, Paris, where he made friends with Maurice Joyant, who became his greatest friend and later his biographer, he was educated at home under the supervision of his mother. When he was fourteen, he covered his exercise books and even the pages of a dictionary with drawings and, when he was fifteen, he did his first paintings, encouraged by the painter John Lewis-Brown and with the help of one of his father's friends, the deaf-mute animal painter René Princeteau. Princeteau's interest may have been the sympathy of one handicapped person for another because, in 1878, the young Toulouse-Lautrec had broken his left femur in a fall and the right femur the following year in a second fall. It left him crippled for the rest of his days and humiliated by a body with the legs of a child, which gave him the appearance that has become so familiar to everyone. He accentuated its grotesqueness by wearing a beard. It may have been a reaction against his fate that gave him the will to achieve greatness in his art, because it was after the second fall that he applied himself to it in earnest. He satisfied his interest in horses, which he could not ride, by vigorous drawings of carriages and riders, and, in 1879, by the painting of the *Gunner Saddling his Horse* (Albi Museum). He never lost this interest; all through his life he drew and painted countless jockeys on their horses and the grooms of the Circus Fernando. At eighteen, he was already an excellent draughtsman, who had mastered the art of recording a realistic feature. This did not prevent Léon Bonnat, whose studio he joined in 1882, from telling him, 'Your drawing is atrocious.' He continued his training with Cormon, where he met Van Gogh and Émile Bernard. He worked there sporadically till 1887. He now had his own studio in the rue Caulaincourt at the corner of the rue Tourlaque, near Goupil's print shop, where all the artists went. Montmartre was his world and its dance-halls, cafés-concerts and brothels were the settings for the masterpieces of the aristocratic dwarf. It seems odd that he did the portrait of

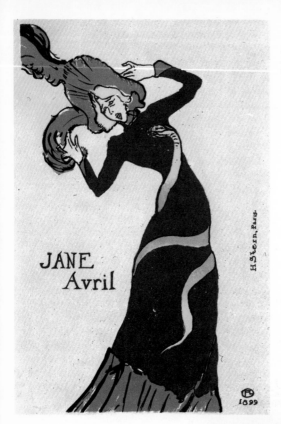

TOULOUSE-LAUTREC.
JANE AVRIL.
1898. POSTER

TOULOUSE-LAUTREC.
THE ENGLISHWOMAN
AT THE 'STAR',
LE HAVRE.
1899.
MUSÉE D'ALBI

154

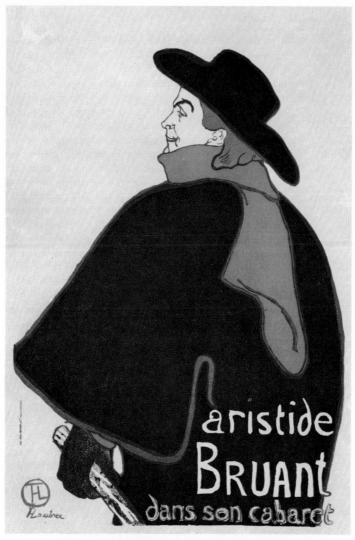

TOULOUSE-LAUTREC. ARISTIDE BRUANT IN HIS CABARET. 1893. POSTER

his mother, the *Comtesse Alphonse de Toulouse-Lautrec in the Drawing-room of the Château de Malromé* (1887, Albi Museum), in the midst of drawings of dancers of the Moulin-Rouge, cabaret singers and prostitutes. One of his acquaintances was Aristide Bruant, who used to sing at the 'Mirliton', whose walls he decorated with paintings. He decorated the covers of Bruant's songs with his first attempts at lithography, like *Saint-Lazare* in 1886. He gradually took his subjects from further afield and the theatres of Paris, the circuses, race courses and cycling tracks were added to scenes of Montmartre night life. He was the most assiduous observer and the most piquant recorder of the world of entertainment and pleasure during the last decade of the nineteenth century. His work is an invaluable document of the period, registered with a realism that was often caustic and sometimes cruel, but that was saved from the extravagances of expressionism by its disciplined draughtsmanship. His numerous portraits in oil, pencil and lithography, even when they are flicked off with a few rapid strokes of brush or pencil, show his psychological insight of the sitter. They reveal the nuances as well as the depth of character of people who have often only remained famous because Toulouse-Lautrec portrayed them; La Goulue, Yvette Guilbert, Jane Avril, May Milton, Jeanne Hading, Berthe Bady, Ève Lavallière, Marcelle Lender, Caudieux and a number of others would have fallen into oblivion if he had not immortalised them. They sometimes appear with a few salient traits on lithographed posters, which are composed with an astonishing originality from ideas borrowed from the Japanese print and its broad areas of flat colour. He designed about thirty posters between 1891 and 1900, which include some of his masterpieces and which had a far-reaching influence on the development of graphic art: *The Moulin-Rouge*, with the silhouettes of La Goulue and Valentin le Désossé, *The Divan Japonais*, *Eldorado*, with Bruant, *The Revue Blanche*, with the figure of Missia Natanson, and the *Troupe of Mlle Églantine*, where there is a typical Art Nouveau arabesque. Lautrec seldom used pastel or watercolour, but he did a fine portrait in pastel of *Van Gogh* (1887, Amsterdam, Vincent Van Gogh Museum). It is interesting to note that some of his paintings have elongated brush strokes that may be due to the Dutch painter. The portrait of

TOULOUSE-LAUTREC.
LA GOULUE
AND VALENTIN.
1894.
LITHOGRAPHY

Oscar Wilde (1895, Private collection, New York) is in water-colour. His favourite medium was spirit-thinned oil paint on unprimed carboard, which allowed him to combine drawing and painting; every brush stroke is apparent on the board that is left partly bare. Notable works in this manner are *Woman with a Black Boa* (1892), *Jane Avril Dancing* (about 1892), *The Female Clown Cha-U-Kao* (1895); all three are in the Musée de l'Impressionnisme. His large pictures, like *At the Moulin-Rouge* (1892, Chicago, Art Institute), *The Salon of the Rue des Moulins* (1894, Albi Museum) and the portrait of *Dr. Gabriel Tapié de Celeyran* (1894, Albi Museum) are in oil on canvas.

About 1898, Lautrec's health began to deteriorate from excessive drinking. In 1899, he had to undergo a cure for alcoholism in the clinic of Dr. Sémelaigne at Neuilly. There, he drew from memory thirty-nine circus scenes, some of which were published in a collection four years after his death in 1905. A good collection of his works can be seen in the

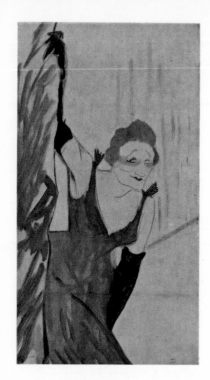

TOULOUSE-LAUTREC.
YVETTE GUILBERT
TAKING A
CURTAIN CALL.
1894.
MUSÉE D'ALBI

TOULOUSE-LAUTREC. IN THE CIRCUS FERNANDO:
THE RINGMASTER. 1888. ART INSTITUTE, CHICAGO

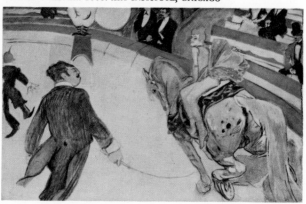

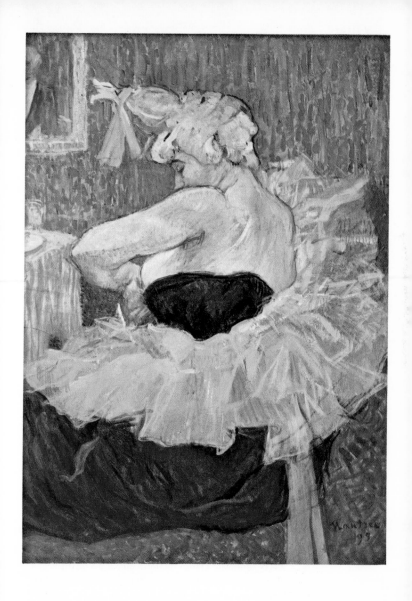

TOULOUSE-LAUTREC. THE FEMALE CLOWN CHA-U-KAO. 1895.
MUSÉE DE L'IMPRESSIONNISME, PARIS

Musée de l'Impressionnisme in the Jeu de Paume, Paris. Besides the works mentioned above, it also contains the *Woman with Gloves* (1889/90), *La Toilette* (1896), *Woman Dressing her Hair* (about 1896) and the two panels he painted in 1895 to decorate the booth at the Foire du Trône, where La Goulue was dancing, her heyday at the Moulin-Rouge long past. She appears on each panel; on one in a pink and green costume, with Valentin le Désossé; on the other, in the Danse des Almées in front of a group of spectators, who included Félix Fénéon. Museums outside France have some fine examples of his work, notably the Art Institute of Chicago with seven works, including the portrait of *Madame Lili Grenier* (1885/8), *The Circus Fernando* (1888), *The Moulin de la Galette* (1889), *At the Moulin-Rouge* (1892); the National Gallery of Washington with the *Quadrille at the Moulin-Rouge* (1892) and the portrait of *Alfred la Guigne* (1894); the Kunsthaus at Zurich with *At the Bar* (1898); the Museum of Modern Art at Prague with *Women Dancing at the Moulin-Rouge* (1892). The largest collection of his works, most of which were donated by his mother, is to be found at the Musée Toulouse-Lautrec at Albi, which was housed in 1922 in the Palais de la Berbie, not far from the Hôtel du Bosc where he was born. It comprises over 200 paintings, including several early studies, 150 drawings and about 100 lithographs. There are some remarkable studies among the paintings: the portrait on board of *M. Warrener* (1892), whose outline with a top hat reappears in a coloured lithograph with the title *The Englishman at the Moulin-Rouge*; the sketch for the fine portrait of *M. Delaporte* (1893) in the Ny Carlsberg Glyptotek at Copenhagen, which also possesses the portrait of *Suzanne Valadon* (1895); and the best drawing he ever did of *Yvette Guilbert* in 1894, with her long black gloves and aggressive nose; the charcoal drawing heightened with colour was the preliminary sketch for a poster, which the singer did not like.

VOLLARD Ambroise (1865 - 1939). Ambroise Vollard began as a clerk in a small art gallery. When he became a dealer himself (1893), he prudently began to take interest in 'recognized' painters. Suddenly, without transition or half-measure, he adopted Cézanne and in December 1895 organized in his

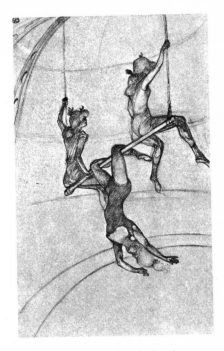

TOULOUSE-LAUTREC.
'AT THE CIRCUS'.
THE FLYING TRAPEZE.
1899. BLACK CRAYON

gallery the first great Cézanne exhibition, with a hundred and fifty of his most characteristic canvases. The show created a scandal; the public closed their ranks. Vollard was forced to remove from his window the canvases that provoked the hilarity or hostility of passers-by. Meanwhile real admirers appeared: Auguste Pellerin, Count Camondo, the former King Milan of Serbia, for example. Vollard's shop, his 'cellar', as it was called, became the most brilliant artistic centre in Paris during the first forty years of the century. A drawing by Bonnard, dated 1895, represents him in the midst of the well-known disorder of his shop, surrounded by Rodin, Pissarro, Renoir, Degas and Bonnard himself. All his friends painted his portrait; Bonnard, Cézanne, Renoir and Picasso among others.

The illustrated book soon became Vollard's main pre-occupation and in the period between 1900 and his death about thirty works appeared under his imprint, which are now among

the most sought after books of bibliophiles. These include Verlaine's *Parallèlement* (1900) with lithographs by Bonnard, Jarry's *Ubu Roi* (1918), illustrated by Rouault and Maupassant's *la Maison Tellier* (1933) with original monotypes by Degas.

Although Vollard's big transaction was with Cézanne, he was none the less interested in artists like the Nabis and Gauguin. He became Gauguin's regular dealer in March 1900 and guaranteed him a monthly allowance in exchange for his paintings. In 1901, Picasso's first exhibition was held at his gallery and he bought from him some thirty canvases for two thousand francs in 1905. The first exhibition of Matisse also took place at Vollard's gallery, in 1904. Vollard had an opportunity to show his fondness for Fauvism by acquiring the whole of Derain's studio in 1905 and Vlaminck's in 1906. Having met Rouault in 1907, he directed him toward ceramics and later toward the illustration of books, eventually installing a studio for him in his own house, where he invited all the artistic and literary élite of Paris for his famous dinners. In addition he brought out bronzes by Rodin, Renoir, Maillol and Picasso. His tremendous activity won him many friendships and enabled people to forgive the redoutable business man that he was. He had a very original personality and his conversation was extremely lively. A respectful but vigilant observer, he executed portraits himself – literary ones – depicting Cézanne, Renoir and Degas in vivid and colourful books. In 1937 he published his *Souvenirs d'un Marchand de Tableaux* (published first in English, in 1936, as *Recollections of a Picture Dealer*), which will remain an important source for the art history of our time.

ZOLA Émile (1840 - 1902). Born and died in Paris. In 1857, Zola met Cézanne at the Collège Bourbon, the future Lycée of Aix-en-Provence. When, in 1861, Cézanne went to Paris, he lived in lodgings, not far from Zola, in the rue des Feuillantines. At the Café Guerbois, which he had been frequenting since 1866, he made the acquaintance of avant-garde critics and the painters who would become the Impressionists. When the editor of the newspaper *L'Événement* asked him to write a series of articles on the Salon that had just opened, Zola launched, under the pseudonym of 'Claude', a virulent criticism

RENOIR.
VOLLARD DRESSED AS
A TORERO. 1917.
FORMERLY
COLLECTION VOLLARD,
PARIS

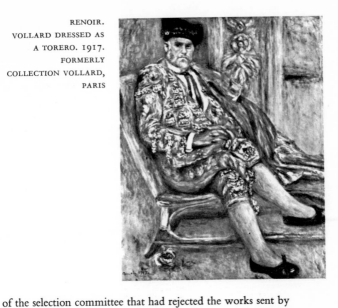

of the selection committee that had rejected the works sent by his new friends, notably *The Fifer* of Manet. The tone of the articles was admirable; it resounded both as a challenge to conformity and a cry of triumph. There were protests from a number of the paper's subscribers and the edit⌐⌐ did not hesitate to sacrifice Zola, who did not admit that ⌐ as he published, in the following year, a ⌐ critical study on Manet in the *Revue du X* ⌐ ⌐ Manner in Painting: M. Édouard Mane⌐ ⌐m eventually triumphed: at the Salon of 18⌐ ⌐urs of the public and the sarcasm of th⌐ ⌐nous portrait of him was received. Contin⌐ ⌐or the Impressionists, he wrote another ser⌐ *énement* *Illustré*, the successor to Villemess⌐ ⌐o doubt Zola was little interested in th⌐ ⌐nique and aesthetic doctrine, but the gro⌐ ⌐s name and the violence of his colourful s⌐ ⌐te a favour- able attitude toward the new⌐ ⌐sonal opinions were by no means object⌐ ⌐ear he already permitted a concern, a do⌐ ⌐the future of the

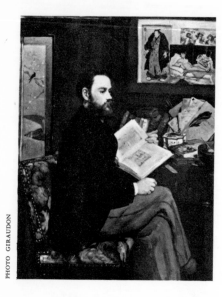

MANET.
PORTRAIT OF ZOLA.
1868.
MUSÉE DE
L'IMPRESSIONNISME,
PARIS

painting whose apostle he had made himself. These doubts took a more serious turn in 1880 when, writing in the *Voltaire*, he attacked the ideas of Impressionism and abused Monet for 'thrashing around in the void for ten years' and for being a 'renegade' like Renoir. The artists retorted by a banquet of protest, at which Camille Pissarro, Duret, Burty, George Moore, Mallarmé, Monet, and others were present. However, Zola once more showed his ill temper toward the painters by publishing in 1886 his novel *L'Œuvre*, in which he represented his former schoolfellow and friend Paul Cézanne as Claude Lantier, a restless painter and a failure.

One can easily discern the reasons behind Zola's behaviour. It was due only to his attachment to realism, which had made him like first Cézanne and then Manet. Fundamentally what he had liked in Monet, Renoir and Pissarro were the first works, quite evidently inspired by those of Courbet. But it should not be forgotten that his action, in 1866 and 1868, was courageous and beneficial, and that is contributed powerfully to causing at least the name of Manet to be respected.

BIBLIOGRAPHY

E. Duranty, *La Nouvelle Peinture*, Paris 1876 (reprinted, 1945).

Th. Duret, *Les Peintres Impressionnistes*, Paris 1878.

J.-K. Huysmans, *L'Art moderne*, Paris 1883.

Th. Duret, *Critique d'avant-garde*, Paris 1885.

F. Fénéon, *Les Impressionnistes en 1886*, Paris 1886 (reprinted in *Œuvres plus que complètes*, Geneva 1970).

G. Moore, *Confessions of a Young Man*, Londres 1886 (revised edition, 1917).

A. Silvestre, *Au Pays des Souvenirs*, Paris 1892.

G. Moore, *Modern Painting*, London 1893.

P. Signac, *D'Eugène Delacroix au Néo-Impressionnisme*, Paris 1899 (reprinted, Paris 1964).

J. Meier-Graefe, *Manet und seine Kreis*, Berlin 1902.

C. Mauclair, *The French Impressionists*, London 1903.

J. Meier-Graefe, *Entwicklungsgeschichte der modernen Kunst*, Stuttgart 1904 (revised and enlarged edition, Munich 1927).

W. Dewhurst, *Impressionist Painting, its Genesis and Development*, London 1904.

A. Fontainas, *Histoire de la Peinture française au XIXe siècle*, Paris 1906 (revised and enlarged edition, 1922).

J. Meier-Graefe, *Impressionisten*, Munich-Leipzig 1906.

V. Pica, *Gl'Impressionisti francesi*, Bergamo 1908.

Th. Duret, *Manet and the French Impressionists*, London 1910.

M. Denis, *Théories 1890-1910*, Paris 1912.

J.-E. Blanche, *Propos de peintres, de David à Degas*, Paris 1919.

F. J. Mather, *Modern Painting*, New York 1927.

R. Rey, *La Peinture française à la fin du XIXe siècle. La Renaissance du sentiment classique*, Paris 1931.

G. Besson, *Peinture française*, vol. III : *XIXe siècle*, Paris 1934.

A. Vollard, *Recollections of a Picture Dealer*, London 1936.

P. Francastel, *L'Impressionnisme. Les origines de la peinture moderne, de Monet à Gauguin*, Paris 1937.

J. Laver, *French Painting and the Nineteenth Century*, New York-London 1937.

W. Uhde, *The Impressionists*, London-New York 1937.

L. Venturi, *Les Archives de l'Impressionnisme* (2 vols.), Paris-New York 1939.

C. Pissarro, *Letters to his Son Lucien*, New York 1943.

C. L. Ragghianti, *Impressionismo*, Turin 1944.

J. Rewald, *The History of Impressionism*, New York 1946 (revised edition, 1961).

G. Bazin, *L'Époque Impressionniste*, Paris 1947 (revised and enlarged edition, 1953).

M. Raynal, J. Leymarie, H. Read, *History of Modern Painting. I - From Baudelaire to Bonnard*, Geneva 1949.

L. Venturi, *Impressionists and Symbolists*, New York 1950.

R. Cogniat, *French Painting at the Time of the Impressionists*, New York 1951.

F. Novotny, *Die grossen französischen Impressionisten*, Vienna 1952.

C. Roger-Marx, *Le Paysage français de Corot à nos jours*, Paris 1952.

C. Bell, *The French Impressionists*, London-New York 1952.

H. J. Wechsler, *French Impressionists and their Circle*, New York 1952.

B. Taylor, *The Impressionists and their World*, London 1953.

D. Cooper, *The Courtauld Collection*, London 1954.

J. Leymarie, *Impressionism* (2 vols.), Geneva 1955.

Dictionary of Modern Painting, London-New York 1956 (revised and enlarged edition, 1964).

J. Rewald, *Post-Impressionism*, New York 1956.

R. Cogniat, *L'Impressionnisme*, Paris 1956.

R. Th. Stoll, *La Peinture impressionniste*, Lausanne 1957.

W. Balzer, *Der französische Impressionismus*, Dresde 1958.

Catalogue des Peintures, Pastels, Sculptures impressionnistes, Musée National du Louvre, Paris 1959.

G. Bazin, *French Impressionists in the Louvre*, New York 1959.

J. Canaday, *Mainstreams of Modern Art*, New York-London 1959.

V. Van Gogh, *Complete Letters* (3 vols.), New York-London 1959.

R. Cogniat, *Le Siècle des Impressionnistes*, Paris 1959.

H. Gardner, *Art through the Ages*, New York-London 1959.

M. Serullaz, *Les Peintres Impressionnistes*, Paris 1959.

F. Mathey, *The World of the Impressionists*, London-New York 1961.

J. Leymarie, *Peinture française: XIXe siècle*, Geneva 1962.

B. Von Grüningen, *De l'Impressionnisme au Tachisme*, Basle 1964.

Th. Burollet & F. Mathey, *The Museum of Impressionism in Paris*, Paris 1965.

J. Lethève, *De 1870 à 1914. Des Impressionnistes aux Cubistes*, Paris 1967.

Les Néo-Impressionnistes (J. Sutter ed.), Paris 1969.

M. & G. Blunden, *Journal de l'Impressionnisme*, Geneva 1970.

J. Leymarie & M. Melot, *The Graphic Work of the Impressionists*, New York 1971.

P. Courthion, *The Impressionists*, New York 1971.

J. Clay, *L'Impressionnisme*, Paris 1971.

/